The Personal Security Handbook

**Practical Tools for Keeping
Yourself, Your Family & Your Things
Safe at Work, Home or on the Road**

**SILVER LAKE PUBLISHING
LOS ANGELES, CA ◆ ABERDEEN, WA**

The Personal Security Handbook

Practical Tools for Keeping Yourself, Your Family and Your Things Safe at Work, Home or on the Road

First edition, 2005
Copyright © 2005 by Silver Lake Publishing

Silver Lake Publishing
111 East Wishkah Street
Aberdeen, WA 98520

•

P.O. Box 29460
Los Angeles, California 90029

For a list of other publications or for more information from Silver Lake Publishing, please call **1.360.532.5758**. Find our Web site at **www.silverlakepub.com**.

The Silver Lake Editors
The Personal Security Handbook
Includes index.
Pages: 288

ISBN: 1-56343-775-9

Printed in Canada

CONTENTS

DL

CHAPTER 1

THE PSYCHOLOGY
OF SECURITY

Most Americans took **inventory of their lives** following 9/11, or at least began to think about where they stood when it came to their level of risk in daily dealings. People began to calculate their vulnerabilities, and how they could minimize exposure to dangers. But they also began to misunderstand true risk and lose perspective on what "security" really means. If someone were to ask you which activity—quitting smoking or stopping weekly commutes on an airplane—would increase your chance of living to the age of 90, what would you choose?

In a world where fast-moving information is the currency, anthrax can circulate through the mail, money moves at the speed of light and identities are as easy to steal as bicycles, traditional notions of safety and security are as outmoded as dictaphones and three-martini lunches.

Yet **people cling to obsolete notions.**

This chapter aims to open your eyes to how risk works...and to give you tools for minimizing the dangers that threaten your self, your family and your

things. These are the tools that people need, regardless of how many political fanatics are trying to hijack planes. Why do you need these tools?

- In the post-industrial world, people are free agents—in their work lives and their personal lives.

- The odds are you don't have a corporate employer or big family living under your roof to help you absorb a personal or professional loss.

- You have to fend for yourself, which means you have to be able to identify, assess and manage risk.

Americans are used to having **large institutions**— corporate employers, immigrant communities, the government—manage risk for them. In the wake of the September 2001 terrorist attacks on New York and Washington, D.C., many people talked about wanting to return to the comfort of traditional values, or going back to having institutions handling risk for us.

But the economic and cultural tides can't be turned back, however comforting that idea might be. Our world grows more decentralized every day; and every person is increasingly responsible for himself. This is an opportunity for great freedom and liberty...but it's also a potential threat. The threat doesn't come from terrorists. It comes from our own bad judgment about what's dangerous and what's safe.

As we recoil from the risks posed by a dangerous world, we surrender our ability to handle...and to manage...circumstances in ways that work for us.

Despite great access to data, a shocking number of people have a bad sense of risk.

> Americans often ignore serious risks (driving reck-lessly, smoking, handing their life savings to swin-dlers) and obsess about trivial ones (terrorism, pes-ticides, breast implants, flesh-eating bacteria).

By underestimating common risks while exaggerating exotic ones, we end up protecting ourselves against the unlikely perils while failing to take precautions against those most likely to do us in.

Most media coverage of risk to health and well-being focuses on **shock and outrage**. The media pays attention to issues and situations that frighten—and therefore interest—readers and viewers. The shock-and-outrage approach creates interesting stories but warps people's sense of risk. As a result, we're scared—and often scared by the wrong things.

Some experts in risk analysis call this response **statistical homicide**—the triumph of long odds over common sense. In other words, the risks that kill people and the risks that scare people are different. A smart person doesn't worry about what's scary; she worries about what's deadly.

You don't have to be Stephen Hawking to understand the basics of risk management and apply them to your everyday life. Risk management isn't exact; it can be manipulated by people with agendas. Still, it offers the best way to **minimize loss of life and**

limb. And its basic tenets can help you live a good life. These tenets include:

- **Relative risk** and **odds ratios** compare the odds that something will happen to a specific group with the odds that the same thing will happen to an entire population. Relative risks are expressed in positive numbers—like 0.8 or 5.3—that mean the specific group is that many times more or less likely than the entire population to experience some event.

- **Correlation is not the same as causation**. To some people, a newspaper headline that reads "Bottled water linked to healthier babies" might seem to mean that bottled water actually makes kids healthy. But it doesn't. A more likely explanation: Wealthy parents are more likely to drink bottled water and have healthier kids because they can afford better care.

- The **law of large numbers** provides a key connection between theoretical probability and observed results. The law of large numbers says that, if you repeatedly take bad risks—or play unfavorable games—though you're uncertain of the results of any given outcome, in the long-run you'll be a loser.

You need to **understand risk** and how various parties use it. "Risk analysis" is a broad term that refers to a variety of analytical tools, including: risk assessment, risk characterization, comparative risk assessment, risk ranking, risk-based priorities, risk-benefit analysis and cost-benefit analysis.

> A one-in-a-million mortality risk means that in every one million people affected, one will die. That's on the average, however, and averages don't tell the whole story. The calculations can be very rough and uncertain. Most risk experts prefer to consider relative risks.

Risk estimates aren't ever exact—and they're susceptible to various and conflicting interpretations.

As we try to insulate ourselves from a dangerous world, we've seemed to surrender our ability to handle the chances of loss that are unavoidable. So, despite their access to information, a shocking number of **people have a bad sense of risk**.

The so-called **"fight-or-flight"** instinct that dominates the basic impulses people feel is a crude version of risk assessment. It works on a gut-instinct level.

On the other hand, technical experts have a different approach to risk assessment. They focus on how likely it is there will be a harmful reaction, and if it happens how bad it will be. Something could have very serious consequences—but, if it is judged to be very unlikely, it is not seen as a serious risk.

We are warned about benzene in Perrier, hijackers on our airplanes and asbestos in our school buildings. The truth: The benzene in Perrier probably wouldn't have hurt you, hijackings remain a statistical insignificance and the asbestos in schools is least harmful if left in place.

Most people's feelings about crime are based more on what they read and see in the media than on experience. The truth:

- If you're not an inner-city resident engaged in crime and carrying a gun, your chance of being murdered is no greater than it was in the 1970s.

- Most people think their chances of dying of a heart attack are about 1 in 20. The truth: It's closer to 1 in 3.

- People also figure the odds of dying in an auto accident during a given year are about 1 in 70,000. The truth: The real figure is 1 in 5,000.

SENSATIONALISM IN THE MIX

People often perceive risk by their ability to control dangerous activities. They're usually less afraid of risks they think they control and less afraid of risks that they understand. So, the things that people are most afraid of are **things they can't control** and don't understand.

The Truth

- If people can choose not to take part in certain activities, their perception of risk decreases.

- The media fills its coverage with opinions (usually from interested parties) rather than facts or logical perspective.

- The media's shock-and-outrage approach doesn't help people assess risks. The fact that someone is upset about a loss they've suffered doesn't say anything about how likely the same loss is to happen to you.

- As a result, we're scared—and often scared by the wrong things.

The government is no better about assessing risk. It spends money trying to regulate risks that aren't really risky, while ignoring genuine risks.

The popular media's focus on startling losses and colorful opinions misdirects people's attention toward trivial risks. We end up terrified of violent crime, crashing airplanes and AIDS among drug-free heterosexuals—all tragedies, but rare ones.

The media coverage of the mad cow scare in early 2004 is proof of how distorted a risk can become in the eyes of the public. The moment one Washington state cow was slaughtered for having bovine spongiform encephalopathy (i.e., mad cow), the possible threat to Americans landed on the front page of almost every paper in the U.S. Talk about the tainted beef industry chewed up the news networks and shifted the media coverage from Iraq to filet mignon. While the talk centered on this "serious public health concern," few debated the actual risk of getting mad cow disease from infected tissues. The chance? Almost zero. And, when you consider that fact you have to eat the brains or spinal fluids of a mad cow to worry about it, it's moot to think about the threat.

Even when media attention turns to more likely risks, it often misses the important points. For example, many news stories involve charges that this chemical or that pesticide causes cancer. But the three main causes of cancer are not the much-publicized pesticides or other chemicals developed since World War II, but **smoking, dietary imbalances** and **chronic infections**. Although media coverage invariably focuses on pesticides and other artificial chemicals:

- Your one cup of coffee contains 10 grams of natural carcinogens—the amount the average American consumes in pesticide residues in one year.

- The average American ingests 10,000 times more natural pesticides than artificial pesticide residues every day.

The main reason the media bungles risk reporting: It's time-consuming, nuanced and long-range.

MISGUIDED HUNT FOR ZERO RISK

One of the most problematic offshoots of misunderstanding risk is the idea that we can live risk-free lives. This idea underlies the attempts that so many people make to insulate themselves from the toughness of the real world.

The average person with a computer has access to virtually all the data people have ever gathered on any given subject. But what does that person do with all that data? Which data does he or she even try to understand? And, better yet, which data is accurate?

Modern technology has made it possible to detect tiny amounts of potentially harmful chemicals that would have eluded discovery in previous generations. This means the government can enact regulations to protect Americans from previously hidden dangers. But when this technological capability is combined with Americans' zeal for zero risk, the result can both distort the political process and disrupt the economy.

> The key to understanding risk is the ability to compare and prioritize losses. This is another way of describing the relative context of risks. It's the object of risk assessment.

Risk assessment shouldn't be foreign to anyone. When medical teams in a hospital emergency room use triage to make sure they treat the most severely injured or ill patients first, they are **evaluating risks and assessing costs** in their broadest sense. When family breadwinners borrow against a life insurance policy to pay medical expenses, they are doing the same thing. These are prudent, common-sense procedures for making difficult choices.

> Risk estimates are typically calculated in one of two ways. Experts look at either the loss of average life expectancy that stems from an activity, or they measure the increased chance of premature death. The two methods—morbidity and mortality—present risk in different lights.

For example: The loss of life expectancy from being 20 percent overweight is 900 days; from radiation emitted by nuclear power plants, 0.02 days.

According to the Harvard Center for Risk Analysis, smoking one pack of cigarettes a day for 40 years gives a person a 13 percent chance of premature death. In contrast, the lifetime chance of premature death due to a multi-car crash with a drunk driver is only 0.3 percent.

A number of technical distinctions mark these statistics. The estimate of **loss of average life expectancy** puts a higher premium on accidents that affect the young. That's because young people have the most life expectancy to lose. In this view, an 85-year-old woman who dies in a car accident has lost nothing because she has already outlived her original life expectancy (about 77 years). But a 12-year-old boy who drowns has about 63 potential years of life. This approach downplays the impact of diseases that take a long time to develop, such as many cancers.

The other approach—measuring the probability of premature death—places more weight on risks that tend to occur later in life. Such analyses put more weight on cancer and less on accidents.

People who can't find a way to compare risk effectively are more inclined to make bad decisions. A number of important miscues suggests that Americans, as a society, make these mistakes fairly often:

- Despite widespread concern about the number of crimes committed in the United States, FBI and Justice Depart-

ment statistics show that the **national crime rate** has remained fairly level for 20 years. It even dropped slightly in the early 1990s. What has changed is the kind of crime being committed—it's grown more violent and more random.

- According to some studies, as many as three-quarters of older white women worry about being the victim of violent crime; black teens don't seem much bothered by that prospect. But the responses should be reversed. The odds of an older white woman being a violent crime victim in a given year are 1 in 370. For a black teenage male, the odds are 1 in 6.

- Statistics from the Centers for Disease Control make it clear that the media—which long ignored or underplayed the threat of AIDS in the gay community—has overstated the threat in the general heterosexual community. AIDS remains confined, by an overwhelming margin, to gays, bisexuals and intravenous drug users.

- Although the number and percentage of heterosexual AIDS deaths have increased considerably in recent years—especially among women—only 6 percent of all adult and adolescent AIDS cases have involved heterosexual contact, the CDC says—and two-thirds of those involved are people who had sex with someone who already had (or was in a known risk group for) HIV infection. Only 2.2 per-

cent of AIDS cases have involved heterosexuals with no other known risk factor.

- We worry about planes, which kill about 200 people a year; we shrug off cars, which kill more than 40,000.

The **relative odds of dying** from hyped diseases and behaviors aren't often compared. Doing so, even in a basic format, begins to prioritize risks.

Consider the **odds, over the course of an average life span**, that you will die from:

- Smallpox..Nearly Zero
- Shark attack.............................1 in 100 million
- The flesh-eating bacteria..............1 in 1 million
- Flood...1 in 700,000
- Plane crash (even frequent fliers)......1 in 500,000
- Heart disease
 from eating a broiled steak a week.....1 in 48,000
- A lightning strike.............................1 in 70,000
- Bitten or struck
 by other mammals..............1 in 55,000
- Contact with venomous
 animals and plants.................1 in 45,000
- Fall involving a bed,
 chair or other furniture.................1 in 5,500
- Exposure to excessive
 natural cold................................1 in 5,000

- Stroke...1 in 1,600

- Accidental drowning...................1 in 1,000

- Living with a smoker.....................1 in 700

- Being a pedestrian
 struck by a vehicle...........................1 in 588

- Cancer...1 in 500

- Heart disease.......................................1 in 388

- Murder by firearm............................1 in 330

- Motor vehicle accident.......................1 in 244

- Intentional self-harm by firearm....1 in 216

- A home acci-
 dent...1
 in 130

- Disease caused by smoking one cigarette a
 day...........................1 in 100

- Disease caused by heavy alcohol consump-
 tion.........................1 in 100

- Disease caused by smoking a pack of ciga-
 rettes a day...................1 in 6

If you don't smoke or drink heavily, these numbers should be pretty encouraging. A non-smoker living with a smoker has a 25 percent increased risk of lung cancer and a 30 percent increased risk of heart disease. Second-hand smoke exposure increases the risk of stroke by 82 percent.

Over the course of your life, you have a one in 23 chance of dying from an injury, whether intentional

or accidental. In one year, you face a one in 91,859 odds of dying from a terrorist attack.

Wondering about the ratio of flu deaths to mad-cow-disease deaths in the United States? In 2003, 36,000 flu deaths to **zero mad cow deaths**. Nuclear power vs. sunburn? While the Chernobyl plant meltdown caused 2,000 cases of cancer, mostly nonfatal, among Russians, melanoma kills 7,800 Americans annually.

Nine of 10 premature deaths are linked to **one of six behaviors**. These are:

- smoking cigarettes;
- overeating;
- misusing alcohol;
- failing to control high blood pressure;
- not exercising; and
- not wearing seat belts in cars.

But even comparing numbers like these invites various caveats and qualifications. As we've seen, statistics having to do with dying focus on one of two factors—**morbidity or mortality**.

Also, some people question the various sources that provide the numbers and the manner in which they gathered the data. (That last point—the nagging matter of *methodology*—is a key issue.)

Understanding how risk affects your everyday life requires two things: the tools of risk assessment and **access to reliable information**.

As a steady parade of dangers, risks and schemes marches on past, the tools of risk management seem fairly straightforward. Getting to the reliable information emerges as the bigger challenge.

> We're surrounded by natural toxins; there are natural pesticides in the food we eat that are some 10,000 times more abundant than what we ingest from chemical sources. We're exposed to natural radioactivity in rocks and in the soil. Even the cleanest air contains microscopic poisons.

Medical researchers have begun to realize that the processes of aging and of cancer are related and that cancers are ultimately caused by damage to cell material from the oxidants created in our cells by natural metabolism. We increase cancer risk just by living a long life.

Nevertheless, the futile hunt for zero risk continues to influence the societal debate over how government should govern, companies should do business and people should live.

The challenge for you, as a smart person in a transient world, is to **see through the confusion** to the important risks you face.

PEACE OF MIND

Not since the height of the Cold War and prior to 9/11 have people questioned so vigorously their safety.

There's no such thing as perfect security. No government or private entity can provide perfect security.

There are certain dangers people must learn to live with, and do their best to either avoid them or limit their impact when they occur. You can't let nightmares of Osama bin Laden or Martha Stewart ruin a good night's sleep. You can't cry over a weak stock market or the fact you kept all your money in Enron for too long. Instead, take proactive steps to reduce the chances of something bad happening.

- Rethink the **balance between work life and home life**.

- Reorder priorities and perhaps a career path.

- Pay attention to your children.

- Focus on the things that you *can* control, or at least have *some* control over.

- Find ways to reduce the stress in your life. Lowering your blood pressure and getting better sleep will make you live a longer, healthier life.

- Learn how to read past the daily influx of sensationalized news ("Nasdaq down, terror up—have a nice day") and put things into perspective.

The media will always talk about the most dramatic piece of news and talk about it like you should be concerned. But once something else happens, the media shifts its focus, leaving you left to wonder:

CHAPTER 1: THE PSYCHOLOGY OF SECURITY

What should I worry about? Most likely, you have nothing to worry about. As one radio executive noted during a major East Coast blizzard that drove stories about terror out of the news, "It was a Saddam-free day—just the break we needed."

PSYCHOLOGY AND CHILDREN

When things go wrong and your personal security is compromised, **dealing with children's needs and concerns** is important. This can be a challenge when you're having a hard time yourself dealing with things. For example, during a disaster, your family may have to leave your home and daily routine. Children may become anxious, confused or frightened. It's critical to give children guidance that will help them reduce their fears.

Children **depend on daily routines**: They wake up, eat breakfast, go to school, play with friends. When emergencies or disasters interrupt this routine, children may become anxious.

Your children (and even other people's children) will look to you and other adults for help. How you react in an emergency gives them clues on how to act. If you react with alarm, a child may become more scared. Your fear is proof that the danger is real. If you seem overcome with a sense of loss, a child may feel their losses more strongly. Calmly and firmly explain the situation. As best as you can:

- Tell children what you know about the disaster.

- Explain what you believe will happen next.

- Encourage children to talk. Let them describe what they are feeling.

- Include the entire family in the discussions.

- Talk with your child and **present a realistic picture**. Be honest.

- Take children's fears seriously, even if they stem from an imagination.

- Provide reassurance with your words and actions. Tell them you're going to do everything you can to resolve the trouble.

- Keep control of the situation, emotionally. Understand that feelings of fear are healthy and natural for both adults and children.

- Ask your children what's on their minds and what questions they want answered.

- Let your children participate in the recovery activities.

The impresions that children have about risk are formed before and after traumas occur. So, you can do a lot to calm childrens' fear by **assuring them after the storm passes**—litertally. Most often, a child will be afraid that:

- The event will happen again.

- Someone will be injured or killed.

- They will be separated from family.

- They will be left alone.

Advice to Parents

☐ Teach your child how to recognize danger signals. Make sure your children know what smoke detectors, fire alarms and local community warning systems (horns, sirens) sound like.

☐ Explain how to call for help. Check the telephone directory for local emergency phone numbers and posting these phone numbers by all telephones. Include 911.

☐ Help your child memorize family information: family name, address and phone number. They should also know where to meet in case of an emergency. If your child isn't old enough to memorize the information. They could carry a small index card that lists emergency information to give to an adult or babysitter.

☐ Keep the family together. You may want to leave your children with relatives or friends. Instead, keep the family together as much as possible and make children a part of what you are doing to get the family back on its feet.

Remember: Children get anxious and worry that their parents won't return. This fear of abandonment can ruin a child's ability to recover from a bad situation quickly. If a child does not respond to the above suggestions, seek help from a mental health specialist or a member of the clergy.

CONCLUSION

The psychology of security is important to understanding the relative risks you face in your daily life. You can't begin to prepare for and plan for the what-ifs until you know how to prioritize those risks and have a clear sense of what's worrisome and what's over dramatized by the omnipresent media.

Being able to filter through the influx of information, alerts, threats, reportings, advice and stories you hear every day in a realistic and educated manner is the best way to protect yourself...and give yourself a true sense of safety.

Later in this book, we will detail the how-tos of dealing with disaster. Whether you face a minor flood from a storm or a massive evacuation from an area in a hurricane's path, you need to know how to prepare, what to do, who to contact and how to deal with the aftermath. It's hard to have a clear head when you're in the middle of a disaster, so having the know-how before is key to ensuring the safety of you and your family.

CHAPTER **2**

PHYSICAL
SECURITY

Of all the risks that ordinary people have to consider in the course of their daily lives, crime was most affected by the terrorist attacks in New York and Washington on September 11, 2001. In this century, those attacks heightened sensitivities toward crime and victimization—leading in some cases to a fascination with violent acts.

> **The media's exaggerated interest in kidnappings during the summer of 2002 can be thought of as a result of the fears stirred up by the 9/11 attacks. There have been many more exaggerations since.**

In reality, kidnappings had gone down in number over the years—but you'd think the opposite if you were keeping up with the news. This focus on victimization is surely one of the **goals of terrorism**. Terrorists clearly intend to make target populations fearful; one way to do this is to convince the population it's a victim.

For these psychological reasons and others, crime statistics are hugely misunderstood. For most Americans, the odds of being the victim of a violent crime dropped between the late 1980s and the early 2000s.

Even before the 9/11 attacks, people believed they were at greater risk of violent crime. For example: A poll commissioned by *Parenting* magazine revealed that 54 percent of parents feared their children might be kidnapped at some point. But, according to federal government statistics, a child's odds of being kidnapped are only 1 in 300,000.

According to criminologists, even though violent crimes touch very few lives, they are a key to **people's sense of safety**.

Does murder make you fearful? Probably. Does white collar crime make you fearful? Probably not. But white collar crime is more likely to affect you (as an employee or an investor) than murder.

When you think of an attacker, you probably imagine an odd-looking stranger. But you're more likely to be attacked by someone you know—especially if you're a woman.

- Seventy-eight percent of women know their attacker (a casual acquaintance or friend);

- Sixty percent of sexual attacks take place in the woman's home;

- A 2001 study carried out by the director of Maryland's health department found that homicide is the most common preg-

nancy-related cause of death in the U.S.—
and, overwhelmingly, the murderer is in
a close relationship with the woman (e.g.,
husband); and

• Generally, crime victimization rates indi-
cate that the never married, the divorced
and the separated experienced violent
crime in 2001 four times as often as mar-
ried and widowed people.

In 2001, there were an estimated 18.3 million prop-
erty crimes including burglary, motor vehicle theft
and theft. There were an estimated 5.7 million vio-
lent crimes including rape, sexual assault, robbery,
aggravated assault and simple assault. Fifty per-
cent of the violent victimizations recorded by the
National Crime Victimization Survey were reported
to the police in 2001, and 37 percent of the property
crimes were reported to the police.

It's easy to blame the popular media for exaggerating
the importance of violent crime risk. Unlike other
risk issues, crime reporting has a long, **sensational-
ized history** in popular media. For example, homi-
cide ranks eleventh in causes of death among men,
but it receives the same amount of media coverage
as the *leading* cause of death among men: heart dis-
ease. Crime stories consume 25 percent of all news-
casts. America's murder rate declined 20 percent from
1990 to 1998, yet network **news coverage of ho-
micides increased by 600 percent** during that pe-
riod.

Despite what the media implies, you have some con-
trol over your odds of being a victim, particularly
when it comes to your behavior. Behavior has some-
thing to do with your chances of being the victim of
a violent crime—if you're a drug dealer, the odds
you'll be shot increase.

Other factors—especially **who you are and where
you are** at a given time—also influence crime rates.

For this reason, the sociological and demographic
patterns that emerge from crime numbers are im-
portant to the odds that you'll be mugged, raped or
killed in the coming year.

INTERPRETING THE STATISTICS

The various influences on crime statistics are explored
in a series of studies done each year by the FBI and
the Justice Department.

The largest and most sophisticated study from vic-
tims is the National Crime Victimization Survey
(NCVS). Every six months, NCVS interviewers con-
tact a national sample of more than 65,000 house-
holds. More than 100,000 individuals age 12 or older
are interviewed and asked to report their experience
with crime.

The NCVS has been progressively refined over the
past 20 years, and it is widely considered to be the

best source of information about rates of crime and violence in the United States. Some of its conclusions include:

- Generally speaking, the crime rate is contingent upon the **number of young men** in the population. The more young men there are, the more crime there is.

- According to the FBI and the Justice Department, more than 80 percent of those arrested are male. And men aged 15 to 34 years account for 70 percent.

- Selective sampling can be made to produce almost any result, but the demographic influence on crime rates is a historical trend.

Demographers predict the most violent-prone segment of the population (15- to 19-year-olds) will grow nearly twice as fast as the overall U.S. population through the year 2010. The younger the person, the more likely he or she is to experience a violent crime.

One of the common mistakes people make about crime is that it's motivated by poverty. There is **no causal connection between poverty and crime**. At best, there is only a correlative link.

Being poor doesn't make you a criminal; being rich doesn't make you a victim. But hanging around in high-crime areas is more likely to make you one or the other. Or both.

Violent criminals tend to be **spontaneous and opportunistic**. They prey on whoever is nearby. The best way to avoid violent crime is to stay away from violent criminals—no matter who you are.

According to the Justice Department, your risk of being a victim does not increase as you make more money—it actually declines. Your odds of being victimized are two to three times lower if you make $50,000 or more a year than if you earn less than $10,000. That's because the wealthier you are, the more likely you are to stay away from criminal activities.

CRIME AND RACE

Race is another correlative factor when it comes to violent crime. The archetypal image—present in so many sensational media stories, cynical political ads and racist fantasies—of a young black male threatening elderly whites is not supported by the numbers. But, as we've seen before, misperceptions can be stubborn things.

Race doesn't make someone more likely to be a criminal. But the correlation between race and violent crime means devastating things for many Americans. Leaving politics as far out of this discussion as possible, the fact is that people allow misperceptions to make them scared when they shouldn't be.

In the United States, young black men are convicted of committing crimes more than other demographic groups; but they are also disproportionately the vic-

tims of violent crime. The rate of homicide among young black men, aged 15 to 35, grew two-and-one-half times worse between the mid-1980s and mid-1990s.

> **The chances of a white woman 65 or older becoming a victim of serious violent crime are just one-seventieth the odds a black male teen faces. But older women worry about crime more than any other group.**

In absolute terms, white people commit more violent crimes than black people—54 percent to 45 percent, according to FBI arrest statistics. But, because there are fewer black people, the impact of the numbers is much more dramatic for their communities.

Every 1 percent of black Americans accounts for 3.5 percent of all violent crimes, while every 1 percent of other Americans accounts for about 0.8 percent of these crimes. But the most important conclusion: People are most often **victimized by someone of their own race**.

Your chances of being attacked vary tremendously according to your age, race, sex and neighborhood. The risk of becoming a victim of violent crime is:

- nearly four times higher if you're 16 to 19 years old than if you're aged 35 to 49;

- almost three times higher if you're black instead of white;

- two times higher if you're male rather than female; and

- two times higher if you live in a city rather than in a suburb or in the country.

So, what can you do to reduce your chances of becoming the victim of a violent crime? Obviously, you can't change your age, race or gender. But you can do something about **how close you are**—physically—to problems, either immediately or over the long term. More specifically, you can:

- Do everything possible to get out of densely-populated city neighborhoods, especially if you are (or are the parent of) a young black male;

- Stay away from public spaces where young people gather, after school or at night;

- Use common sense; avoid shady, unpatrolled areas where there are many unlit corners; and

- Remember that you're most likely to be attacked by someone of your race and age group—so don't assume you're "safe" because the people on the street look like you.

Only under the most extreme circumstances would you need to **hire a bodyguard**. Bodyguards are expensive and the luxury of celebrities and public personalities. If someone is threatening you and you fear for your life when you go out or sit at home, talk to your local police department about what you can do.

STALKING

Stalking is a **set of many behaviors** (e.g., telephone harassment, sending unwanted gifts, pursuing or surveillance) that can come from a variety of individuals with very different backgrounds, motivations and psychological disorders. Although women are most likely to be stalked by a male predator, women can also stalk men.

A stalker who harbors delusions that the victim is in love with him performs behaviors that are often similar to an ex-partner who seeks revenge for being rejected. But there are many reasons for why someone might stalk you, and they don't always have to be related to a previous relationship gone sour.

Increase Your Awareness

- Do not overlook the signs of unwanted attention.

- Heed your intuition alerting you to danger.

- Harassment/stalking often begins as minor annoying encounters so be attentive to early warning signs prior to the escalation of these behaviors.

Responding

- Although "letting someone down easy" may seem conscientious, it can inadvertently provide a mixed message.

- Give a firm and definite "No," to communicate that you are not interested in a relationship of any kind.

- When receiving unwanted attention, you shouldn't respond at all. If it is too late or unavoidable, don't use statements that can be misconstrued.

Making Reports

- Any suspicious activities should be reported to the police.

- Threats (from minor or vague to severe or specific) should be treated seriously and immediately reported to the law enforcement.

Protect Your Privacy

- Identifying or personal information should not be entered into online profiles/directories.

- Encourage others to keep your personal information confidential.

- Never give out your Social Security number over the phone or enter it online.

- Lock all your doors and windows.

- Install motion detectors and/or a home security system.

- Avoid walking/exercising alone.

- Consider a cell phone and/or beeper.

- Be more vigilant with your children and keep your pets inside at night and when you're away.

What to Do Initially

☐ Tell the unrequited person that no further contact of any kind is allowed.

☐ Be assertive and inform him/her that the relationship is over.

☐ Maintain a firm and direct demeanor.

☐ Avoid using tones or phrases that could be misconstrued as implying a second chance or playing hard to get.

☐ Discipline yourself to avoid contact with the stalker: This includes all contact (calling to ask for someone else's phone number, counter-harassing, sending letters back, etc.), which could easily be misinterpreted by the stalker.

If you're being stalked by your ex-partner, and you're thinking about getting a restraining order, some experts suggest first getting help from an objective party (i.e., a threat management team) familiar with the stalking research literature and well-informed about the details of your particular stalking situation.

A restraining order (or protection order—depending on your state's legislation) may actually escalate the stalking events as well as provide a victim with a false sense of security and lead to carelessness.

> Many communities offer some type of assistance for victims. Local law enforcement, mental health centers and justice centers may provide either assistance or referrals to assistance programs. The Attorneys General for each of the 50 states should also offer information on local victim assistance programs.

CRIMINALS ARE OPPORTUNISTIC

Street criminals are not masterminds. Criminals act opportunistically: They aren't usually in the mental condition to plan complex crimes. According to The Sentencing Project, a Washington, D.C.-based criminal justice policy group, "Half of all violent offenses are committed by people intoxicated on alcohol or other drugs."

> In most cases, violent criminals tend to be young because few people make a career out of crime. Most criminals realize that crime poses enough risks to life and liberty that a straight job—even one near minimum wage—is usually a better deal.

Consider also:

- Larceny is a risky and low-profit line of work. If a thief nets 50 percent of what he or— less likely—she steals, he or she would have to commit six or eight crimes a month just to live at a subsistence level.

- Law enforcement officials and politicians often refer to crime as a pathology or disease. This rhetoric usually has little bearing on the odds an average person will be a victim of crime in a given period.

However, in the June 14, 1995, issue of the *Journal of the American Medical Association*, academics from Emory University in Atlanta and the city's Police Chief performed an epidemiological study of home invasions during a three-month period in 1994. The results support the characterization of crime as an opportunistic phenomenon.

A total of 198 cases were identified during the study interval (cases of sexual assault and incidents that involved cohabitants were excluded). A few key distinctions emerged:

- the ethnic makeup of victims closely resembled the demographic composition of the city;

- the victim and offender were acquainted in nearly one-third of the cases;

- a firearm was carried by one or more offenders in 32 cases—fewer than 1 in 8; seven offenders carried knives;

- stealth was the most common method of entry (80 cases), followed by force (59 cases); offenders used deception (for example, knocking on the front door) followed by force in 12 cases;

- fifteen percent of the intruders entered through the front door of the house; 24

percent, through a back or side door; almost all of the others gained entry through a ground floor window; and

- forty-seven percent of the crimes occurred between midnight and 6 A.M.; 17 percent occurred between 6:01 A.M. and noon; 16 percent, between noon and 6 P.M.; and 20 percent, between 6:01 P.M. and midnight.

PROPERTY VS. VIOLENT CRIME

The cases studied in the Atlanta report combined violent crimes and property crimes. This combination reflects a key bit of confusion that most people have about crime: They **confuse violent and property crimes**. This confusion is important for several reasons.

First, property crimes are more common than violent crimes. According to the Bureau of Justice Statistics, in 2002, 76 percent of crimes were property crimes while only 23 percent were crimes of violence. Yet, most people state that they are most worried about being attacked violently. Murders were the least frequent violent victimization—about six murder victims for every 100,000 persons in 2001.

Second, the most effective responses to each type of crime are different. The Atlanta report found that resistance to thieves can be effective, while resistance to violent crime may only cause more and greater violence. In the Atlanta report, the sequence of events in each crime fit one of three general patterns:

- No confrontation occurred in 42 per-cent of the cases because the intruder ei-ther entered and left silently or fled the moment he or she was detected.

- Forty-nine victims (25 percent of the to-tal) confronted the offender but did not attempt to resist.

- Sixty-two victims (31 percent) resisted the offender.

Some victims resisted passively by running away, locking a door or holding on to their property; most resisted actively by fighting back, screaming or calling 911.

Victims who avoided confrontation were more likely to lose property but much less likely to be injured than those who confronted the offender. Consider this data:

- Resistance was attempted in 62 cases (31 percent).

- Forty cases resulted in one or more vic-tims being injured, including six who were shot.

- No one died.

- Three victims (1.5 percent) used a gun in self-defense. All three escaped injury, but one lost property.

- The odds of injury were not significantly affected by the method of resistance.

The main conclusions of the study reflect **basic common sense**. The best way to prevent a home invasion crime is to make your dwelling hard for the opportunistic criminal to enter. In other words, lock your windows and doors. And keep some lights on.

> **Confronting an intruder is likely to get you hurt. And having a gun doesn't improve your chances of confronting a criminal without getting injured.**

Crime tends to be a **geographically-sensitive risk**. Robert Figlio, a University of California, Riverside, sociology professor, says, "It's *where you are* even more than *who you are* that determines whether you will be a victim."

So avoid the occasion of trouble.

> **In a 1998 survey conducted by the Bureau of Justice Statistics in 12 cities nationwide, the percentage of residents in each of the 12 cities who said they were fearful of crime in their neighborhood ranged from 20 percent in Madison, Wisconsin to 48 percent in Washington, D.C. and Chicago, Illinois.**

STATISTICAL QUESTIONS

Criminologists complain that annual crime rankings of cities are inaccurate and nothing more than a creation of headline-hungry journalists who oversimplify

surveys that were never intended to produce comparisons among cities and states.

Local law enforcement authorities have wide discretion in the way crimes are reported and classified. This is an important point because:

- The FBI counts only crimes reported to the police—just a fraction of actual crime.

- The Justice Department, which surveys victims, concludes that nearly two-thirds of all crime goes unreported nationally.

- So, even a small difference in willingness to report crimes can have a big effect on the actual "crime rate."

When it releases its report each December, the FBI assigns no rankings and does no calculations to compare different cities or states. It even warns against doing so because there are too many other factors that come into play. Among those factors:

- population density;

- degree of urbanization;

- high concentrations of youths or transients;

- poverty;

- unemployment;

- family stability; and

- climate.

Crime numbers can vary dramatically—even within a single metropolitan area. And the FBI report consid-

ers metropolitan areas, not individual cities. So, the cities with the highest crime rates sometimes are in metro areas farther down the list.

GADGETS AND GUNS

There are lots of ways to protect yourself with things: bodyguards, Mace, pepper spray, stun guns, baseball bats, firearms, etc. New gadgets arrive on the market every year, selling to fearful consumers who don't know how else to feel more secure. As mentioned earlier, owning a gun for personal security (assuming you're not an avid hunter) is more likely to harm someone in your family than a potential intruder or assailant.

According to supermarket salesmen, the most popular personal security products are pocket-sized cans of pepper spray, which contain Oleoresin-capsicum.

Capsicums are chilli peppers that occur in many varieties that range from mild to hot. Capsicum encompasses 20 species and some 300 different varieties of pepper plants. Oleoresin is the industrial extraction of the dried ripe fruits of capsicums and contains a complex mixture of highly potent organic compounds.

They are easy to use, and can be found small enough to carry on your keychain. You simply aim and depress the button that emits the spray.

The effects are instantaneous, causing inflammation of the capillaries in the eyes and all mucous membranes, resulting in immediate temporary impairment of vision, coughing, choking and nausea with extreme discomfort. Symptoms disappear within 30 to 40 minutes with no other effects. Some, however, argue that these sprays have a heightened effect on those with allergies and asthma.

- Replace canisters every 18 months.

- Check local laws; some cities/states make it illegal to carry Mace or pepper spray without a permit.

You can buy pepper spray in the form of a lightweight pen with a five-meter range, and others combine oleoresin pepper spray and chloroacetophenone (CN) tear gas (known by its more popular brand name, Mace), as well as a ultraviolet marking dye, which aids in the capture of the assailant.

- Some canisters come equipped with high-decibel alarms that will attract attention.

- When shopping for sprays, find one that has a light easily activated. The entire device should be easy to use. Single-function devices are best.

- Read all instructions before using.

Stun guns can be purchased with the click of the mouse and in some retail stores. They're small enough to fit inside a purse, and some cost less than $15.

- Stun guns deliver a high voltage, low amperage shock, causing a stunning effect. It disrupts the signal from the brain to the muscles, causing the assailant to drop.

- The assailant suffers a loss of balance, muscle control, confusion and disorientation.

- Stun guns range in power. The higher the voltage, the less time it takes to incapacitate someone. An 80,000-volt weapon can take up to two seconds, while a 625,000 can take someone down immediately.

- Recovery takes about five to 10 minutes and the assailant (usually) suffers no permanent damage.

More police departments and civilians are turning to stun guns as a non-lethal way to battle criminals. But more and more, stun guns are turning up in the hands of criminals themselves.

Some states, like Illinois, make it illegal for anyone other than police officers to carry stun guns. But they've gotten popular so quickly that no laws have been set up to keep vendors from selling and shipping them.

WORKPLACE SAFETY

Making your workplace safe is just as important as making your home safe, but it's not always as easy. For the most part, you have to rely on your employer

to provide a secure and comfortable environment. This can refer to simple things like having ergonomic work stations, to implementing specific policies to reduce accidents and incidents that threaten the lives and well-being of employees.

Your company should have polices that every em-ployee knows, as well as a **written plan** for dealing with violence, disaster, harassment and general risk management. People are working longer hours and taking on heavier work loads, which contributes to an overall increase in workplace stress.

Some Tips Related to Workplace Safety

☐ Understand your company's policies and **employee manual** in its entirety;

☐ Understand your company's complaint procedures;

☐ Know what to expect when you're at work and something happens (e.g., natural disaster, terrorist activity, fire, etc.);

☐ Know **how to best evacuate** from your location, and how to contact your fam-ily;

☐ Have a secondary plan for surviving a disaster at work if your company's plan cannot be executed;

☐ Keep **important numbers** at work that you wouldn't normally need during the day (e.g., doctors, pediatricians, children's

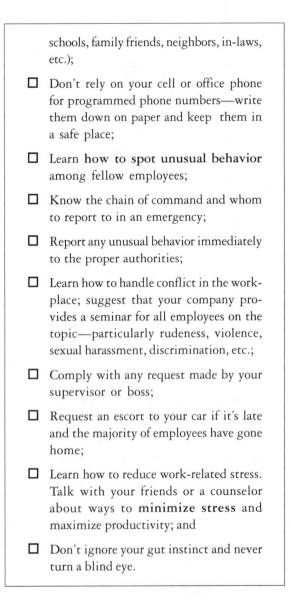

schools, family friends, neighbors, in-laws, etc.);

☐ Don't rely on your cell or office phone for programmed phone numbers—write them down on paper and keep them in a safe place;

☐ Learn **how to spot unusual behavior** among fellow employees;

☐ Know the chain of command and whom to report to in an emergency;

☐ Report any unusual behavior immediately to the proper authorities;

☐ Learn how to handle conflict in the workplace; suggest that your company provides a seminar for all employees on the topic—particularly rudeness, violence, sexual harassment, discrimination, etc.;

☐ Comply with any request made by your supervisor or boss;

☐ Request an escort to your car if it's late and the majority of employees have gone home;

☐ Learn how to reduce work-related stress. Talk with your friends or a counselor about ways to **minimize stress** and maximize productivity; and

☐ Don't ignore your gut instinct and never turn a blind eye.

The chance of you becoming the next victim in a workplace shooting is small; more likely, you'll wit-

ness a subtle form of workplace violence—harassment, discrimination and worker discontent. The culture at work is collective, so it begins with you. Being an active, compassionate employee will do more for your safety than sitting back and assuming your workplace will take care of everything for you.

MORE ON WORKPLACE VIOLENCE

Since essentially everyone in the U.S. works for at least part of his or her adult life, being hurt or killed in the course of employment is a risk everyone has considered at some point.

While the growing interest in non-fatal workplace violence is hard to support with numbers, fatal workplace violence—that is, workplace homicide—is easier to quantify.

Before the 1980s, murder in the workplace was rare; now it is one of the fastest growing types of homicide in the United States.

- **Workplace homicide** is the leading cause of death for women on the job, accounting for more than a third of all work-related fatalities among females. (A workplace homicide victim is defined as someone who is murdered while performing his or her job.)

- Most people still underestimate the number of workplace homicides that occur each year.

- Since 1980, an average of 23 people become victims of homicide at work each week.

Most of these workplace homicides happen when thieves or other criminals kill workers who happen to be in their way.

As a result, some of the risk factors that may increase the chance of homicide in the workplace include:

- exchange of money with the public;

- working alone or in small numbers;

- working late at night or during early morning hours;

- working in high-crime areas;

- guarding valuable property or possessions; and

- working in community settings (taxicab drivers, police, and so on).

Close to 80 percent of workplace homicides are associated with robbery—often of convenience stores and liquor stores open at night. An additional 11 percent of victims are police officers or security guards.

The occupational groups with the highest number of work-related homicides were sales (33 percent), service occupations (20 percent), transportation operators (12 percent), executives, administrators, managers (11 percent) and taxicab drivers and chauffeurs (9 percent).

People skeptical about a workplace homicide crisis argue that unless you drive a taxi, are a police officer or clerk at a convenience store, you don't have much to worry about. But a growing number of workplace homicides occur during confrontations between personal acquaintances.

Domestic violence and stalking know no boundaries—not class, race or sex. Women sometimes stalk men, and even other women. FBI statistics show that women are killing their husbands and significant others at a growing rate. Unfortunately, reliable numbers are hard to find in these matters. No one knows how often estranged spouses or jilted lovers harass and eventually kill their jilters. But employers have reported increasing numbers of **jilted lovers stalking women** in the workplace, perhaps because more women are working and leaving their abusers, who know they can find them at work. The only place a batterer can find a woman is at work.

The average worker faces the greatest risk of hurting herself or himself seriously from rather mundane tasks—lifting too much weight or typing too fast for too long. These kinds of injuries occur as much as 50,000 times more often than more flamboyant risks—like being shot by an irate ex-spouse or lunatic co-worker. The time you spend worrying about risks in the workplace are better spent making sure you work in a comfortable chair, delegating labor-intensive tasks to the most fit employee and learning how to reduce stress.

COMMON SENSE TOOLS

Throughout this book, we will reiterate the power of common sense. Your best weapon against crime, violence, terror and disaster is simple common sense. If you're a single young female who volunteers at a community rec center in a crime-ridden neighborhood at night, you'll have a different set of security issues to consider than a white male who commutes to and from a downtown office and a posh high-income neighborhood.

Marital arts classes have become popular among women, and are not a bad thing if you want to learn some physical mechanics to personal defense. Courses in the martial arts can help you become more aware of your surroundings—and heighten your observational skills. There's always something to be said for being in shape and **leading a healthy life** so when you need to rely on your fitness, you'll survive!

Physical Security Tips

- Awareness and assertiveness can prevent up to 80 percent of all assaults.

- Honoring gut feelings can do a lot to prevent a physical confrontation.

- Taking a self-defense course will heighten your ability to detect abnormalities in your surroundings.

- Always be on the lookout for unusual circumstances. When in doubt, get out.

- Avoid areas that carry red flags: over-crowded, ill-patrolled/unsupervised, dark, no exits, rowdy crowd, funny odors, feelings of being out-of-place and any area that just gives you the willies or makes you feel strange, etc. If something doesn't feel right, it probably isn't.

- Careful when using public transportation (especially subways, trains and buses) or public restrooms late at night.

- Always use cabs from reputable companies with visible licenses.

- Consider getting a cell phone for emergencies.

- Vary routines so you cannot be tracked or easily followed on a daily basis.

CONCLUSION

Personal security covers a wide range of topics and issues, some of which we discussed in this chapter. Having a clear and realistic sense of safety will allow you to decide what steps you need to take or what items you need to buy to be safe.

The events of 9/11 caused many people to overreact and worry too much about things that were least likely to affect them—or affect their security—in their lifetimes. Instead of changing their diets and losing 20 pounds, Americans, for example, hunted down gas masks, body suits and prepared panic rooms for when they needed to lock themselves inside.

Knowing how to get out of a sticky situation quickly is probably better than stocking up on cans of pepper spray or getting a permit to carry a gun. And there's nothing more valuable than your **wit and clear head** for making fast decisions when it comes to finding escapes.

HOME AND AUTO SECURITY

According to United States Department of Justice statistics, in 2001 there were about 18.3 million property crimes (burglary, motor vehicle theft and household theft) and 5.7 million violent personal crimes (rape, sexual assault, robbery and both simple and aggravated assaults).

So, by far the most common threat to homeowners is burglary.

> Burglary is a non-confrontational crime, committed mostly during the day when no one is home or in the evening when there are obvious signs the home is vacant.

The Justice Department reports that 70 percent of all homeowners will be victims of burglary at least once in the next 20 years. Although incidents of crime may be decreasing due to added patrols and home alarm systems, the violence factor of crime is increasing. Because many burglary attempts end up in un-

planned confrontations, it's more serious than a simple property offense.

People are also more aware of kidnappings these days following highly-publicized abductions like that of Elizabeth Smart.

Controlling **access to your home** includes controlling who enters and leaves on a regular basis *with your permission*. An unscrupulous character might get to know you, get invited into your home or work in your home for a given amount of time...then later inflict harm on your family or surreptitiously steal from you when you're not looking. Think about:

- housekeepers;
- security patrollers;
- gardeners;
- repairmen (cable, phone, utilities, appliances, computer, etc.);
- contractors;
- decorators, landscapers;
- caregivers, babysitters;
- deliverers (supermarket, drugstore, food, etc.);
- movers, installers;
- large item deliverers (appliances, TVs, furniture, etc.);
- mailman, garbageman;
- exterminator;

- utility meter reader (gas, electricity, etc.);

- pet groomer;

- tutor, after-school teacher (music, math, etc.);

- athletic coach, personal trainer; and

- friends, neighbors, children's acquaintances, etc.

Limit the number of people who have assess into your home. This means keeping keys and access codes to your security alarm away from most. It's better to be present when visitors arrive at your home for a purpose than to allow people to let themselves in.

Educate your children about the dangers of unwelcome visitors or people who don't have any relation to family members. Tell them to ask for permission from you before they invite anyone into your home. Express the importance of knowing who is coming into the home and for what purpose.

> Many children have a breezy notion of security. They will let anyone who seems to be an authority figure—a postal employee, security guard or utility employee—through the door. Discourage this habit. Even though they know the mailman, for example, this doesn't mean they should feel that they can invite him or her into the kitchen for a refreshment...especailly when you're not at home.

Prevent Unauthorized Access to Your Home

☐ Limit the number of house keys you and your family members possess; do not store extra keys in obvious locations (e.g., kitchen drawer, entryway table, under the front doormat, etc.);

☐ Keep doors locked at all times;

☐ Avoid patterns in your daily schedule;

☐ Secure sliding glass doors with door-jambs;

☐ Consider purchasing a home alarm system, motion detectors, driveway alarms, glass break detectors and video surveillance at front door;

☐ Install deadbolts on all main doors to the outside;

☐ Alert potential intruders of your security by posting warning decals (e.g., "Warning: Electronic Protection by Acme Security"); and

☐ Install visual deterrents like a gate and an electronic garage door.

HOME SECURITY CHECKLIST

An isolated remote location provides less security than one that has reasonably close neighbors. Consider the availability of law enforcement and fire department protection at your home...and do the following:

- Have a **home security survey** conducted by a police officer, firefighter or crime prevention specialist; if you work in a large company with its own security, consider asking a qualified member in your company's security department to conduct the survey for you.

- Implement the recommendations in the survey.

A sample home security survey is included in **Appendix A** at the end of this book. Such surveys regard iuses like door and window hardware, interior and exterior lighting, alarms and family living habits.

Potential intruders often will stake out a target for a few days prior to making an entry. They will look for patterns in your living—when you leave in the morning or come home at night, the times and days of your children's extracurricular activities, where you like to grocery shop, etc. Building change into the patterns of your life may prevent a trespass as much as the look of a heavily guarded home.

Home Security Survey Overview

☐ Test the security systems regularly and insure that family members are following the survey recommendations.

☐ Keep doors locked at appropriate times.

- ☐ Use a door viewing device to identify callers before permitting entry.

- ☐ Never hide keys outside the home.

- ☐ Install secure door chains.

- ☐ Develop sufficient rapport with your neighbors to watch out for each other's homes, especially during trips, vacations, etc. Get involved.

- ☐ Observe unusual activity and report it immediately to law enforcement.

- ☐ Arrange for a neighbor to take in mail, newspapers and packages during your absence.

- ☐ Keep shrubs trimmed. Lush overgrown shrubs can shield intruders, abductors, rapists and rodents.

- ☐ Use a timing device to activate lights and a radio or television in the home during your absence.

- ☐ Keep at least one good fire extinguisher on each floor (especially the kitchen) and make sure your family knows how to use them.

- ☐ Keep flashlights in convenient locations and replace batteries regularly.

- ☐ A dog can be an excellent deterrent to an intruder. If you have a dog, remember that:

 - Exercising the dog on a set routine should be avoided.

- A large dog door can admit intruders.

- Adequate insurance is essential. Even intruders can sue.

☐ Children are an important part of the security plan:

- Don't share details of your travel schedule. They love to tell secrets.

- Teach children not to give out personal information on the telephone.

- Insure that they know how and when to call for assistance.

☐ Telephones and telephone numbers are an important consideration:

- Beware of wrong number calls. Insure that family members don't give your identity or address to the caller.

- A series of wrong number calls should be reported to the telephone company.

- Home telephone numbers should not be listed in company employee directories.

- Make sure that fire, ambulance and police numbers are adjacent to telephones. Or, include these numbers on speed dial.

☐ Have strange packages left by the door. If a signature is required, have the claim slip passed under the door or through the mail slot.

☐ Do not publicize travel plans and avoid work-related photos of family members.

KIDNAPPING

According to the National Incidence Studies of Missing, Abducted, Runaway and Thrownaway Children (NISMART), there are nearly 800,000 children reported missing each year (more than 2,000 per day).

- 58,200 children are abducted by nonfamily members.

- 115 children are the victims of the most serious, most long-term abductions (stereotypical kidnappings), of which 56 percent are recovered alive, 40 percent are killed.

- 203,900 children are the victims of family abductions.

The largest number of missing children are "runaways"; followed by "family abductions"; then "lost, injured or otherwise missing children"; and finally, the smallest category, but the one in which the child is at greatest risk of injury or death, "nonfamily abductions."

The most important thing you can do to prevent abduction is to maintain healthy communication with your children and spouse. Teach your child important telephone numbers and where to go in case of an emergency.

The murder of a child who is abducted is a rare event. We mentioned earlier that child abductions are easily dramatized by the media, leading many to believe that

they happen a lot…and on a regular basis. But they don't, especially when you consider that most aren't abductions at all—children run away from home.

About 100 murders of an abducted child occur in the United States each year, less than one-half of 1 percent of the murders committed; however, 74 percent of abducted children who are murdered are **dead within three hours** of the abduction.

Keep in Mind

- Telling children not to talk to strangers is not usually effective. "Stranger" isn't a concept children easily understand. Teach you children **how to look for threatening behaviors and situations**. If they know how to follow their gut instinct for when trouble lurks, they'll be better equipped to move away from the situation.

- Children should be taught that if they are lost or in trouble, to **seek out a person in a uniform**, such as a policeman, or a familiar neighbor or friend. If they can't find someone who fits that description, they should ask for help from a pregnant woman or a woman with children. These are low-risk strangers.

- Your children need to feel comfortable talking to you about any situation that makes them uncomfortable or suspicious. They should know that they won't be punished for confessing something that happened and didn't feel right.

Remember: There are **no more kidnappings today than there were 10 years ago**. In fact, statistics point to a decrease in the number of child abductions.

But with the media's attention on dramatic cases like kidnappings of Elizabeth Smart and Danielle van Dam, it's hard to put the actual risk of your child being abducted in perspective.

Contact the National Center for Missing & Exploited Children's (NCMEC) Office of Public Affairs by calling 1-877-44-NCMEC, extension 6351, or 703.274.3900 for more information.

MINIMIZING RISKS

The following tips can help reduce the rsk that you or your family faces of becoming a kidnap victim:

- Build change into the patterns of your life.

- Avoid the same commute every day, leaving and arriving at the same time.

- Don't perform errands at the same stores on the same day at the same time of day.

- Don't make it easy for someone to track where you are at any given moment of the day, based on your previous day's schedule.

- Don't advertise what you make. If you boast about your million-dollar salary in

bonuses, people you'd least expect would learn about that money, too.

- Don't give away private information at events that gather lots of people, strangers included (e.g., weddings, large parties, awards ceremonies, holiday gatherings, graduations, etc.).

- Instruct your family and business associates not to provide information concerning you or your family members to strangers.

- Avoid giving unnecessary personal details in response to inquiries from information collectors that would be used in publications such as business directories, social registers or community directories.

- Establish simple, effective signal systems that, when activated, will alert your business associates or family members that you are in danger.

- Be alert to strangers who are on your property for no apparent reason.

- Refuse to meet with strangers at secluded or unknown locations.

- Always advise a business associate or family member of your destination when leaving the office or home and what time you intend to return.

- Lock all doors and roll up windows of your vehicle while traveling to and from work.

MORE SUGGESTIONS FOR PARENTS

The following suggestions are tentative and incomplete, but might **reduce the chance of your children being kidnapped**:

- Make certain that outside doors, windows and screens are securely locked before retiring at night.

- Keep the door to the children's room open so that any unusual noises may be heard.

- Be certain that the child's room is not readily accessible from the outside.

- Never leave young children at home alone or unattended, and be certain that they are left in the care of a responsible, trustworthy person.

- Instruct the children to keep the doors and windows locked and never to let in strangers.

- Teach the children as early as possible how to call the police if strangers or prowlers hang around the house or attempt to get in.

- Keep the house well lit if it is necessary to leave the children at home.

- Avoid obvious indications that you are not at home. Opened garage doors with no cars and newspapers left outside the house are obvious indications that you are away from home and that your children may be inside unprotected.

- Instruct people who work in the home not to let strangers in the house.

- Do not advertise family finances or routines. Kidnappers frequently have their victims under surveillance for several days prior to the abduction, to acquaint themselves with the family's habits.

FOR SCHOOL AUTHORITIES

It's worth including a list of suggestions that your child's school should be following to prevent the unauthorized taking of your child. Parents put an enormous amount of **trust into institutions** that care for and educate their children during the day. You might not have a direct say in how your children's school takes precautions against crime, but you can ask questions and ensure that the school's practices meet your expectations. If not, you can always look elsewhere for your child's care and/or education.

- Whenever possible, before releasing a child to anyone except the parents during the school day, a teacher or administrative official should telephone one of the child's parents and/or guardians for approval.

- When a parent telephones a request that a child be released early from school, the identity of the caller should be confirmed before the child is permitted to leave.

- If the parent is calling from home, the school should check the request by a re-

turn telephone call, during which the child should identify the parent's voice.

- In the event the telephone call is not being made from the child's residence, the caller should be asked intimate questions about the child. These questions might include the child's date of birth, the courses he or she is studying, names of teachers and classmates, and similar facts that should be known to the parents.

- If there is any doubt, do not release the child.

Faculties of schools should be alert to observe suspicious persons who loiter in school buildings and on the surrounding grounds. If such persons cannot readily provide a logical explanation for their presence, the police should be notified immediately. The identity and description of all such suspicious persons should be obtained.

Schools, as well as parents and youth agencies, should take steps to make sure that adult supervision is provided in school and recreational areas.

SUGGESTIONS FOR CHILDREN

The following suggestions should be expressed to your children as soon as they are old enough to travel alone. If they walk to and from school—even

if the school is a block away—they should be aware of these tips:

- Travel in groups or pairs.

- Walk along heavily traveled streets and avoid isolated areas where possible. If you walk on the side of the street facing traffic, you can run away from the direction of a strange vehicle.

- Refuse automobile rides from strangers and refuse to accompany strangers anywhere on foot.

- Use city-approved play areas where recreational activities are supervised by responsible adults and where police protection is readily available.

- Immediately report anyone who molests or annoys you to the nearest person of authority.

- Never leave home without telling parents where you will be and who will accompany you.

- Carry identification with you; know your name, address, home phone number, etc.

IF YOU'RE KIDNAPPED

If you believe you're being followed, go to the nearest police station or try to disappear into a crowd. But sometimes this is not possible, and you will be snatched when you least expect it. Adult kidnappings in the U.S. are almost always **related to money**. This

is why avoiding the advertisement of your fortune is key. Bank branch managers and their families are particularly at risk.

Each year, the FBI investigates 350 to 400 domestic kidnappings, with ransom involved in one-third of the cases. Fortunately, executives kidnapped in the United States can count on the FBI and local police working on their behalf. But if you've been kidnapped in a foreign country, you are in greater jeopardy. In some foreign countries, the local and state police may be your kidnappers.

If you're an executive traveling to one of the world's danger zones—the Middle East, South America, some parts of Asia—you are at risk of being kidnapped. In Colombia, where more than 3,700 kidnappings occur and $250 million in ransom payments are made each year, the kidnapping of foreigners and well-to-do locals has become a way of life for rebel armies and gangs of criminals. (See Chapter 8 for more on "fees," bribes and related foreign travel tips.)

When You've Been Abducted

- ☐ Keep your captors talking.
- ☐ Stay calm, don't debate anything.
- ☐ Do as you are told and don't volunteer anything.
- ☐ Figure out what they want; if it's money, try to convince them you can get it.
- ☐ Touch everything you can in your surroundings. Your fingerprints in a vehicle

> or a building may help police to solve the crime.
>
> ☐ Look for an escape route.
>
> ☐ Take care of your needs—eat what you can and mentally prepare yourself for a long stay.

These tips are also good for children so long as they are old enough to understand them.

CARJACKING

Carjackings have become a newsworthy event, many of them leading into televised car chases at high speeds in metropolitan areas.

A carjacking is a vehicle theft, attempted or accomplished, where force or threat of force against you is used. A federal law amended by Congress in 1994 makes it **a federal crime** to take a car by force "with the intent to cause death or serious bodily harm."

> In the worst case scenarios, carjackings involve not only theft of the vehicle, but violent crimes against the victims as well, including kidnapping, rape, assault, robbery and murder. Unfortunately there is no way to know the offender's intentions until it is too late.

One approach used by some carjackers involves deliberately bumping your car, simulating an accident and causing you to stop.

You're most likely to be carjacked if you have stopped your car at a stop light, drive-up window, parking lot or other location. Shopping malls, car washes, gas stations and ATMs are typically vulnerable locations. You are vulnerable every time you enter or exit your car, and more so if you are loading or unloading goods. Some tips to consider when getting into your car:

- **Be aware of your surroundings—** people lingering nearby or approaching you.

- Keep your eyes on your surroundings until you are safely locked inside your car.

- Check the back seat before getting into your car.

- Listen to your intuition; if someone sitting in a car or standing nearby makes you uncomfortable, take extra security precautions.

- If you are about to get out of the car, use caution.

- **Avoid isolated areas and empty parking lots.**

- Always keep windows and doors locked whenever possible.

- Park in highly visible (i.e. well-lit) locations and seek out other people who could come to your aid.

- Roll up your windows, lock doors and move to another location if you don't feel comfortable getting out of your car.

- If you've made many purchases and are worried about getting to your car safely, **ask the store for an escort.**

- Avoid using your cell phone while approaching your vehicle and/or while loading and unloading your vehicle. The call will distract you from what is going on around you.

- Have your **keys ready in hand** so you don't have to search through your purse or pockets to find them.

Do not resist a carjacker. Ninety percent of injuries and deaths in commercial robberies are the result of resistance. If you find yourself in a carjacking situation, try to cooperate with the carjacker's demand.

If you are trapped inside your car, consider honking to attract attention. Drive away if at all possible. If a gun is in your face, cooperation is your safest maneuver. Make no sudden movements and make no hostile comments.

Every situation is different, so you'll have to sort out your options according to the situation at hand. If someone tries to kidnap or harm you, resistance is usually a good idea...unless the person wields a

> gun. If you are kidnapped and placed in the trunk, rip out wires and/or break out taillights to attract attention. If you hear friendly voices nearby, pound on the car and call for help. Some cars can be opened from the inside, so look for a latch.

Other tips:

- **Separate car keys** from other keys and from identifying information that would lead the perpetrator to your home.

- Keep a cell phone in your pocket so you can call for help if stranded. Write down your license plate number and have it available, along with the make, model and color of your car. Think about getting a cell phone with a camera (either way, you should have a disposable camera in your glove compartment).

- Always leave room between your vehicle and others to allow for escape opportunities

If you get into a situation where you are fearful of your life, call someone nearby or call police. Tell them your location and the circumstances, and ask them to stay on the line while you sort out the situation. Do the best you can to recall a description of the offender, including race, gender, height, weight, hair color and clothing.

If someone bumps you from behind and you don't want to pull over immediately, continue to drive slowly to the nearest location where there are other people around to protect you. You do, however, run

the risk of that person speeding away, leaving you with damage to your rear bumper. In either case, do your best to catch sight of the person and his or her car.

> If you can, get the license plate number, make, model and color of the car behind you. It can be difficult sometimes to gauge whether or not you should pull over, but that'll be a judgment call to make in the moment depending on the circumstances.

Exchanging information with a stranger poses certain risks, too. If you feel obligated to exchange information at the scene, as the law normally requires when you're involved in an accident, consider remaining in your vehicle with the doors and windows locked. **Information can be exchanged verbally through the window**. If at all possible, leave yourself room to drive away if the other party pulls out a weapon. These are particularly important considerations for young women traveling alone.

To prevent a carjacking, you might want to consider some **high technology options**. These include fancy car alarms that require a code to be entered every time the car door opens and closes. Some alarm systems can simulate a mechanical breakdown once the car has been driven a short distance, allowing you to escape on foot while the offender will most likely abandon the car. You can then return with police to retrieve your car.

You can install **satellite technology** that can help locate your stolen vehicle, or call a security dispatch center that can pinpoint your location and send help. Some systems on the market are more aggressive, such as Bingo Auto Defense, which will shoot pepper spray at the push of a button, disabling anyone standing outside the driver's window.

CONCLUSION

Burglary, kidnapping and carjacking—all of which are access control issues—are scary to think about. Most people will experience a burglary at some point (successful or not), but not necessarily a kidnap or carjacking.

According to the Insurance Information Network of California (IINC), **light, time and noise** are a burglar's three worst enemies. Research shows that if it takes more than four or five minutes to break into your home, the burglar will go elsewhere.

According to the IINC, nine out of 10 break-ins could be prevented if homeowners took steps to "burglar proof" their homes. The organization recommended the following tips for homeowners to help protect their homes.

Tips to Review

☐ "Case" your home the way a burglar might and look for easy entrance points.

☐ Protect your doors with solid locks. If you have sliding glass doors, secure them with deadbolts. Eighty percent of break-ins are through a door.

☐ Consider a home security system that will sound an alarm if triggered.

☐ Leave blinds and curtains in their normal positions.

☐ Don't allow trees and shrubs to conceal doors.

☐ Never hide your keys outside; burglars know where to find them.

☐ Use automatic timers for lights, radios and televisions to make the home appear "lived in."

☐ Lower the sound on your telephone ringer and answering machine.

To encourage these precautions, many insurance companies offer a discount for devices like deadbolt locks, smoke/fire alarms and burglar alarms that make a home safer. These companies will usually offer their own checklists for securing your property.

In Chapter 12, we'll discuss the **value of insurance** for protecting your home and valuables. Insurance is like a home security stamp, giving you greater peace of mind than just knowing that you've turned off the oven and locked your doors.

In the next chapter, we cover another vulnerable spot that most people face today and that doesn't necessarily have to do with the workplace or office: computers.

They are ubiquitous in American homes and easy points of entry for thieves and villains. Protecting your computers is like putting a padlock on the cellar door that houses all your personal information.

4

ONLINE RISKS &
HOME COMPUTING

Few people are *not* on the Internet nowadays. If you don't have access at home or at work, there's a store, library, friend, school or relative willing to show you. The Internet opens many doors, both for you to the outside world, and for others looking to come into your home via your computer. As much as a personal tool the Web can be, it can also be a tool for others to **access your personal information**.

Take action to help safeguard your personal computer from: damage or misappropriation of your **software and data**; viruses; objectionable content; intruders contacting **your children**, etc. There's a lot to protect when it comes to your computer and several things you can do to minimize unwelcome consequences to your privacy and computer security. In this chapter, we'll consider how.

ASSESSING YOUR RISKS

To know how vulnerable you are when it comes to computing, ask yourself:

- What is your computer used for?

- Who has access to your computer? Family? Roommates? Friends? Anyone?

- What kind of Internet connection service do you have? (cable? DSL?)

- How often is your computer online as opposed to offline?

- What sort of security features do you have on your computer? Firewall? Content advisor settings? Anti-viral software?

- What kind of sites are you or other users visiting when on the Web?

- What kinds of transactions are taking place on your computer?

- What are your children doing on the Internet? Do they have unsupervised access?

Tips When Making Online Purchases

☐ Check seals of approval links to verify merchants' authenticity (e.g., TrustE, BBBOnline, BizRate, etc.);

☐ Call companies on the phone to judge their legitimacy;

☐ Read privacy policies;

☐ Verify electronic security protocols;

☐ Know what a merchant will do with your personal information;

☐ Know how to tell when a transaction gets encrypted and for the "lock" icon at the bottom of your browser; and

☐ Check your monthly statements for transactions that don't look familiar.

The key to noticing a secure Web site is in the URL. When you log on to a Web site, take a look at where you see the "http" in the address, after which there will be a semicolon. If you're on a site that's supposed to be secure, such as a place where you make actual purchases and input personal information, you'll see an "s" pop up in the URL after the "http." For example, when you go into Amazon.com and you're starting to buy something, it's going to say "https" at the very top in that URL page.

- *http://www.amazon.com* is not a secure URL on Amazon's site; but

- *https://www.amazon.com* is a secure URL on the site.

You can also go to *www.bizrate.com*, a Web site that displays e-business ratings by consumers.

Make sure every Web site you patronize has a toll-free number, which gives you the ability or the opportunity to call in your order. Any good, legitimate outfit will offer a number (many of them toll-free) on the home page, giving you the option of ordering over the phone.

E-MAIL PRECAUTIONS

Viruses typically spread through e-mail, particularly attachments. Double-clicking on an **infected attachment** can easily drop a bug into your system that will wreak havoc. To prevent this from happening:

- Be wary of all attachments and verify all senders;

- Do not open attachments from unknown senders;

- Save any attachment you want to open to your hard drive so your anti-viral software can act on it;

- Encrypt any e-mail you want to keep private; and

- Keep your anti-viral software updated.

If you or someone in your family uses **Instant Messaging** (IM), understand that you pay a price for the convenience of this service: It's not private or protected. Let your family know that if anyone wants to send an e-mail containing private information, that it's best to use a regular e-mail account and encrypt the message.

Chat rooms are another place where personal information can get out. Online chats provide an arena for a countless number of listeners.

> Caution any IM or chat room users in your family to avoid sending any messages that contain private or personally sensitive information.

Resisting all forms of online commerce is the safest way to go...but probably an impractical one today. If you cannot resist purchasing online, consider using online cash equivalents like PayPal instead of using a credit card.

Downloading and swapping anything through the Internet—even through e-mail—can be risky. If you play games online, download files from another gamer during game play or download/swap other forms of entertainment like music, video, pictures, software programs, *free*ware, photographs, books, magazines, etc., watch out.

Know where your downloads are coming from. If you happen to download a virus or worm, you might set in motion a sequence of events that leads to the total crash of your system.

So-called **Trojan horse programs** are a particular problem in peer-to-peer file sharing. They are innocuous programs that, once activated, destroy your computer. Before you download anything:

- Look for a digital signature on the file you are attempting to download;

- Accept files only from people or companies you know and trust; and

- Keep your anti-viral software up-to-date.

There are many options when it comes to anti-viral software. If you use Outlook, for example, for your e-mail, you can install Microsoft's Outlook E-Mail Security Update, which will protect you from vi-

ruses that spread via e-mail attachments. You can install anti-viral software from many sources, or purchase a program like McAfee, Norton (Symantec), TrendMicro, etc. Be sure to register your anti-viral software and keep it updated (i.e., upgraded).

- Customize your anti-viral software's settings, telling it how you want it to deal with things like pop-up icons, advertisements and cookies, etc., and by having the program run regular checks on your system.

- Scan your disk drives on a weekly basis and check your system whenever you're not using it.

- Click on your anti-viral software's icon once in a while to make sure the program is active.

WHEN YOU CATCH A BUG

You'll know that your computer has caught a bug if it suddenly starts **acting weird**. It might slow down, exhibit a lot of modem activity or refuse to open applications correctly. What to do:

- Get the latest "virus signature file" from your anti-virus vendor's Web site. There will be a specific inoculant for your particular virus;

- Follow the procedures for eradicating your particular virus;

- Run your virus protection scan and see if your software can effectively remove it all;

- Delete all infected files; and

- Inform anyone you might have infected.

> Having to deal with viruses means having to delete files when they become infected. This makes it all the more important to back up your files on a regular basis. Don't expect to back up your files if they are already infected with a bug. You might have to lose some recent information, but you won't lose the majority of your virus-free data.

Be careful about **pop-up screens** that ask if you'd like such-and-such site to become your Home Page. You might wind up with a pornographic site or some other unwanted site set as your default home page.

If you find your computer defaulting frequently to pornographic sites, you might have a virus lurking in your machine, a rogue program created by hackers—a Trojan horse—that infected your machine during your innocent Internet surfing. The virus could be gathering material without your knowledge and storing stuff on your hard drive.

Any Web site can contain a Trojan horse. If you ever visit a site offering legal adult fare, gambling or even a music file-swapping site, you could be exposed to malicious software.

E-MAIL ETIQUETTE

The speed of e-mail for communicating with friends, co-workers, colleagues, business contacts and family has made it a powerful and commonly used tool in daily living. But it can be dangerous when it comes to mixing personal messages and work-related ones while in the office—including the home office.

Employers have started to implement **policies related to e-mail** and how it can be used and abused. After a subsidiary of Chevron lost a multi-million dollar sexual harassment case that sprung from an e-mail listing 12 reasons why beer is better than women, companies have taken preventive measure to protect themselves from such cases.

Some employees have lost their jobs by sending e-mails with sexual or harassing content around the office. The New York *Times* fired 22 staff members, for example, in 1999 when they forwarded dirty jokes, just as Dow Chemical had done to 75 of its staff the same year.

The vast majority of Americans with access to e-mail and the Internet at work are being monitored by their employers. And employers are allowed to monitor workers online—from the kind of mail they send to how long they spend on the Internet and what kinds of Web sites they visit.

Some companies allow employees to tap into their at-work computers while at home using password-protected technology. This erases the barrier between offices away from the home and inside the home.

Snail mail is the safest way to send messages. If you need to send someone a content-sensitive message, avoid electronic mail entirely. E-mail is never private...and is more exposed than a message on a postcard.

Your password does not protect you from hackers, snoops or any officer with a warrant to subpoena your e-mails in professional or personal legal matters. Two things to note before hitting Send:

- What would Mother think?
- Would I feel comfortable writing this in longhand, signing my name and putting it in a mailbox?

Don't assume that your e-mail messages are deleted once you hit delete. Even if the companies policies state that e-mail is deleted after 30 days, it is not gone. **Deleted e-mails** can be retrieved...and used in courts of law. If you don't take precautions now when it comes to managing your e-mail etiquette, you'll find that it can haunt you for a very long time.

About those Out-of-Office Replies: Despite their utility, out-of-office or out-of-town replies can be dangerous, exposing you to criminals who seek out absent employees and vacant homes. You wouldn't leave an outgoing message on your answering machine that tells people that you're on vacation and will be back in three weeks. So, don't do the same with your e-mail. Keep details of your messages

down to a minimum; don't give out job titles; don't
mention holidays; and don't include personal con-
tact details.

An out-of-office/town reply is an **alert to potential
thieves**. Keep criminals guessing about whether your
absence from your desk means that your house is
unoccupied.

SECURITY MAINTENANCE

As mentioned above, it's vital to keep your **security
features updated**. If you registered your anti-viral
software, you'll get updates and advisories automati-
cally sent to you. Take advantage of these updates
and apply patches when they become available (these
are small fixes to your anti-viral software package).
Plan to update regularly:

- Operating system (e.g., Windows, OSX, etc.);

- Internet browser;

- Applications (e.g., Microsoft Office ap-
 plications);

- E-mail;

- Anti-virus software; and

- Firewall.

If you customize your security settings, check them
on occasion to make sure no one else has changed

them without you knowing. You can tell your computer how to handle downloads, certain Web sites, cookies and other content. You can manage access to sites according to ratings for language, nudity, sex and violence.

> **Understand that security is a trade-off. The more secure your computer, the less access you have to everything on the Internet. Enabling more features and functions means enabling greater potential for something bad happening to your computer and personal information. It's up to you to decide how much you're willing to risk...and how much you're willing to sacrifice for your protection.**

Firewalls add an important gate to your system. The fewer holes (i.e., "ports") you have in your system from which an intruder can break and enter, the better protected your system. A firewall helps block unauthorized entry into your computer and restricts outbound traffic. It's like having one more security feature on your home to prevent intruders from trying to enter. There are three kinds of firewalls:

1) **Personal, software firewalls**: This will cost you anywhere up to $50 per computer. If you use Microsoft Windows XP, you have a built-in firewall. Other brands to check out that supply firewalls: Symantec, McAfee, Zone Labs, Sygate, Zero-Knowledge Systems and Internet Security Systems.

2) **Hardware routers**: These are not firewalls technically, but they perform a similar function by masking your computer's address and ports to outsiders. For less than $100 you can hook up a four-port router to up to four computing devices.

3) **Hardware firewalls**: These units are more for business systems than home systems, as they are more expensive (at least $400) and complex to manage.

Manage your firewall as you would manage the other security features you have on your system. Check for and install software updates. Review the traffic that passes your firewall. Find out how much probing traffic your firewall is repelling. Do no activate the "Always On" feature of your computer. If you have DSL or a cable modem, turn off your connection when you're not online.

A firewall restricts unauthorized access to your computer. If you want to manage access from you computer to certain Web sites, you can change the settings in your browser or use an online filtering service.

Checklist of Things to Do on a Weekly Basis

☐ Back up your system and all files, keeping them in a secure location away from your computer;

☐ Update anti-viral software and other wares; and

☐ Scan your files using your anti-viral program.

Twice or more a year, change your passwords, verify that your subscription to your anti-viral software is still current; if not, renew it. Also, reevaluate how extensive your security features should be depending on changes to the use of your computer.

PDAS AND OTHER ELECTRONIC DEVICES

The world has gone wireless. That means convenience on one level and a security nightmare on another.

- Wireless technology can quickly connect computers and broadcast every bit of transmitted information in the meanwhile to anyone with a computer and a $40 wireless networking card. So, a man with a hand-held PDA can walk down a busy street in Manhattan and tap into your computer four floors up a nearby building, or while you're drinking a latté in the nearby coffee shop, working on your laptop.

- There are dozens of ways to use these wireless programs on wireless hardware to snatch someone else's Internet access, IDs, passwords...and peep into the private affairs of individuals and businesses.

Because wireless technology relies on radio signals, a walk-by hacker can reach not only an intended target, but any compatible equipment within a several-hundred-foot radius.

You want to safeguard the information you store on any hand-held device—your Palm Pilot, BlackBerry, PocketPC and the like—from hackers, loss or theft. Products are finally emerging on the market that safeguard such information, as PDAs are being loaded with increasingly sensitive information—patient records, contact lists, price sheets, financial records and other proprietary information.

These applications work on a wide range of devices with multiple layers of security. Users must enter a password to access encrypted data. If you try several times and fail to log on within a given time, the device will dump its files. Any safeguards loaded onto a PDA cannot be turned off by an individual user. Hewlett-Packard, for example, has a series of iPaq PDAs with a built-in fingerprint scanner and wireless LAN support that makes its PDAs more secure than earlier versions.

Tips for Users of Wireless or PDAs

☐ Avoid using a wireless network when in close proximity to insecure areas where strangers can access your data; this could be in parks, arenas, airports, street corners, coffeehouses, public transportation or any heavily-trafficked public area.

☐ Think about limiting your wireless network to home use (unless you have curious neighbors!).

☐ Consider purchasing applications for your PDA that will safeguard the information you carry on it.

☐ Do your homework before making any purchases; don't sacrifice personal security for dollars.

A WORD ABOUT PASSWORDS

If you were to tally up **how many passwords** and PINs you currently have, you probably have more than one. You *should* have many more than one. Between the codes you need to access your bank accounts, you have ones for your computers, e-mail accounts, voice mailboxes, cell phones, debit cards, credit cards, online subscriptions, online Web sites, online banking, online financial accounts (e.g., investing), various memberships to clubs, frequent flyer programs, merchants, etc. The list goes on and on.

Because everything we sign up for today often requires a password or code, it's no surprise that many of us use the **same old password** for multiple purposes. The one we use at the ATM is the same one we use to log into the New York *Times* or *msn.com*. Having the same password across the board is not the safest thing to do. Someone can probably figure out that password if he or she worked hard enough.

The goal: Use a system of passwords. Do not use the same old password for everything. Get crafty.

Place *different* passwords on your credit card, bank and phone accounts. Avoid using easily available information like your mother's maiden name, your birth date, the last four digits of your Social Security number, or your phone number or a series of consecutive numbers. When opening new accounts, you may find that many businesses still have a line on their applications for your **mother's maiden name**. Use a password instead.

Tips to Creating a Secure Password

☐ Create a word you can remember, but someone else can't guess.

☐ Use at least seven characters, including upper and lower case letters, numbers and symbols.

☐ Use at least one symbol character in the second through sixth position.

☐ Use as at least four different characters in your password (no repeats).

☐ Use a sequence of random letters and numbers.

☐ Avoid any part of your name, logo, birth date, mother's maiden name, etc.

☐ Avoid any actual word or name in any language.

☐ Avoid using numbers in place of letters.

☐ Avoid reusing any portion of an old password.

☐ Avoid using consecutive letters (i.e., abcdefg) or numbers (i.e., 4567).

☐ Avoid using adjacent keys on the keyboard (i.e., asdfjkl;).

The trick is to create a word you can remember, but that someone else can't guess. The worst but most popular password is "PASSWORD" so avoid that word at all costs.

MORE PASSWORD TIPS

• Create tricky passwords for protecting very important information or for any online transaction where your credit is at stake (i.e., shopping, banking, mutual funds, brokerage, investment retirement accounts, money management software, tax preparation software, auctions, insurance, etc.).

• Create simple passwords for accessing less critical information like online magazines, newspapers, chat rooms, etc.).

• Avoid the "Remember my password" feature on most sites, unless you know those sites are secure.

• Avoid sharing your password or writing it down (and sticking it to your monitor!).

- Change passwords every six months or more frequently.

Monitoring Your Online Accounts

☐ Review your accounts online frequently to spot transactions you didn't authorize, such as online credit card charges, mutual fund transfers, bank account withdrawals, etc.

☐ Review monthly statements you receive in the mail for unauthorized activity.

☐ Call an account if you don't receive a monthly statement in the mail.

☐ Get a credit check annually to see if anyone has opened new accounts in your name.

How would you know if someone stole your password and began using it to pretend to be you for various reasons on- and offline?

You'll only know for sure if you spot unusual activity in your accounts or if you don't receive a monthly bill or statement. If an identity thief changes the mailing address for your accounts, you may not know you have a problem until you get a phone call from a collection agency...or you're denied credit.

Think of your password as a key to your home and everything you own—including your credit and ultimately, your reputation.

Online Activities to Avoid

- Auctions;

- Financial transactions (trading, banking, applying for loans, including mortgages, obtaining insurance quotes or other info that require personal information);

- Chat rooms; and

- Online retail or other purchasing.

FAMILY PHOTOS ON THE WEB

The Internet provides a huge window of opportunity for criminals. With the easy availability of family Web pages on the Internet, be cautious about the kind of information you post there.

Posting pictures of the inside of your home on the Internet for friends and family to see might seem like fun, but the photos give a thief a road-map of what type of valuables are there and where they're located.

Things *Not* To Post Online

- The itinerary for your upcoming vacation;

- Information or photos about collectibles or other valuable possessions;

- Family information, names, favorite places, memories or information about your heritage;

- Information about your child, such as his or her age, photos, after-school activities, friends or hang-outs; or

- Your address, place of business, family names or information about who you do business with.

Minimize the amount of personal information you put online by designating one credit card for making your online purchases. This limits the number of accounts open for exploitation across the Internet.

Internet criminals often use **unsolicited commercial e-mail**, known as "**spam**," to commit Internet fraud and identity theft. Spam can be used to target unsuspecting consumers and lure them to official looking Webs sites—such as a billing center for an online service provider or the front page of a mortgage information form. When users enter passwords, SSNs or credit card information, the information may be taken and used or sold by identity thieves.

To prevent being duped in this fashion, practice the following 10 points:

1) Never purchase spam-advertised products.

2) Always protect your personal information—assume that anything online may become public.

3) Never send personal information to e-mail requests. (You should never be asked

for a password, credit card number or SSN from a legitimate source via e-mail.)

4) Verify every transaction.

5) Beware of get-rich-quick schemes.

6) Never pay "up front" for loans or credit. Legitimate lenders generally do not "guar-antee" a loan or credit card before you apply.

7) Refrain from clicking on Reply or Re-move. Some senders may remove your address, but others may flag your e-mail address as "live," and send you more spam or even sell the address to other spammers. Instead, **forward spam to the FTC** at uce@ftc.gov.

8) Use a "public" e-mail address when online. Set up and use a public e-mail address—either an additional address from your ISP or a free e-mail address. Use this e-mail address when participat-ing in newsgroups, joining contests or anytime that your e-mail is requested by a third party online. Potential spam will go to your public e-mail address instead of your private e-mail address.

9) Be careful when you post your e-mail address online. You'd be surprised how often you use your e-mail address online for newsletter subscriptions, to join online groups or in chat rooms. Before you post your e-mail address, know whether it will be displayed or used. Then **use a public e-mail address** (i.e., one you set up

with Yahoo! or Netscape to be used solely for Internet commerce purposes) when necessary.

10) Use an e-mail filter to help eliminate unwanted e-mail.

LOOK-ALIKE E-MAIL SCAMS

As we've mentioned, one of the ways ID thieves get your information is by "pretexting" or fooling you into giving your information to someone who seems important. This can happen easily over the phone ("Hi, I'm calling from Verizon with some questions about your account because there seems to be a problem...") but it can also come in the form of an e-mail that looks real—with company logos and links back to the legitimate company's site.

You might get an e-mail from "eBay" that asks you to click on a link to verify your account information, which then takes you to a criminal's Web page...and a few clicks later, your personal data is in the hands of an identity thief.

This is called "**phishing**," and it involves stealing a company's identity to use in a scam for victimizing consumers, then stealing their credit identities. These e-mails usually contain a threat designed to trick consumers into entering their information (e.g., "Your eBay account will be suspended. According to our site policy, you will have to confirm that you are the real owner of the eBay account by completing the following form or else your account will be deleted.")

Another that went around the Internet came from Microsoft Network (MSN):

> We regret to inform you that technical difficulties arose with our July 2003 updates. Unfortunately, part of our customer database, and back-up system became inactive. We will require you to enter your information in our online billing center at your convenience. Or by calling our customer support team. The average hold time is 45 minutes.

Never reply to such e-mails. Legitimate companies don't usually ask for this kind of personal financial data over e-mail. Be wary of e-mails that urge you to click on a link to a Web page that asks for financial information. Links appearing in HTML-based e-mails cannot be trusted because programmers can easily make a link to a criminal's page look like a harmless link to a site like eBay.com or PayPal.com. Tips for avoiding scams of this kind:

- If you get an e-mail that warns you, with little or no notice, that an account of yours will be shut down unless you reconfirm your billing information, do not reply or click on the link in the e-mail. Instead, contact the company cited in the e-mail using a telephone number or Web site address you know to be genuine.

- **Avoid e-mailing personal and financial information**. Before submitting financial information through a Web site, look for the "lock" icon on the browser's status bar. It signals that your information is secure during transmission.

- Review credit card and bank account statements as soon as you get them and look for unauthorized charges. Know when all of your closing dates on your cards are, and if your statement is late by more than a couple of days, call your credit card company or bank to confirm your billing address and account balances.

- Report all suspicious activity to the FTC.

Visit www.ftc.gov/spam to learn other ways to avoid e-mail scams and deal with deceptive spam. The FTC works for the consumer to prevent fraudulent, deceptive and unfair business practices in the marketplace and to provide information to help consumers spot, stop and avoid them.

CONCLUSION

Federal legislation is emerging to help consumers combat some of the problems perpetuated by computers. Among the more serious problems, however, facilitated by the conveniences afforded by modern technology is identity theft. If you think of how many times during the day you have the opportunity to expose critical information about yourself to strangers—whether it's online or when you're waiting in line to use the ATM—it's frightening.

Originally, the subject of identity theft was part of this chapter. But because there is so much to say when it comes to preventing and dealing with identity theft, we've dedicated the entire next chapter to it.

5

PROTECTING YOUR IDENTITY

Identity theft has become the **fastest-growing crime problem** in the 2000s; over 40 percent of all consumer complaints in the U.S. involve identity theft. ID theft happens when someone steals a piece of personal information about you and uses it to commit a fraud.

ID theft will cost U.S. consumers and their banks or credit card companies more than $1.4 billion in 2004. By 2006, losses could reach $3.68 billion.

The thief might steal your Social Security number, name, date of birth, credit card information, bank account numbers, mother's maiden name, etc., and use these things to:

- Open up new accounts;
- Change the mailing address on your current credit cards;
- Rent apartments;

- Establish services for utility companies;

- Write fraudulent checks;

- Steal and transfer money from a bank account;

- File bankruptcy;

- Obtain employment;

- Establish a new identity;

- Apply for a mortgage, car loan or cell phone.

Once someone assumes your identity to get credit in your name and steal from businesses, you probably won't realize it happened until months later. Federal law limits a consumer's liability for credit-card fraud to $50 per account. Visa and MasterCard have adopted zero-liability policies, but the real problem remains in the clean-up of your credit report.

> According to a survey conducted by Privacy Rights Clearing and the California Public Interest Research Group, victims spend from $30 to $2,000 on costs related to identity theft, not including lawyer fees. The average loss: $808. (Interestingly, the FTC reported in December 2001 that 16 percent of all identity theft victims reported a loss of more than $10,000.)

And don't think that ID theft is only a hassle for adults. About 2 percent of identity thefts involve a child's Social Security number. Parents should check their

children's credit history reports as they would their own for signs of theft. If your child receives mail, like unsolicited credit cards, this may point to someone assuming your son's or daughter's identity to establish credit.

ID thieves do not discriminate. Whether you're young, old, rich or poor (famous or infamous) you are at risk. Celebrities like Tiger Woods and Lara Flynn Boyle have been victims. But there is one thing that can make you a greater target for ID theft: **your name.** According to the U.S. Census Bureau, the more common the name, the easier the target.

What's in a Name?

- The most common family names include: Smith, Johnson, Williams, Jones, Brown, Davis, Miller, Wilson, Moore and Taylor.

- Most common male names: James, John, Robert, Michael, William, David, Richard, Charles, Joseph and Thomas.

- Most common female names: Mary, Patricia, Linda, Barbara, Elizabeth, Jennifer, Maria, Susan, Margaret and Dorothy.

Your **location** might elevate your risk as well, as the largest number of ID theft complaints have typically come from California, New York, Texas and Florida. ID theft can be extremely lucrative for criminals. A clever thief can walk away with over $10,000 per

victim. The bigger the city, the easier it is for the thief to disappear. Other facts about ID theft released by a Federal Trade Commission survey:

- About **half of victims do not know** how the identity thief obtained their personal information. Nearly one out of four victims said their information was lost or stolen—including credit cards, checkbooks, Social Security cards or stolen mail.

- One out of 25 of those surveyed said identity thieves misused their personal information to evade law enforcement, such as presenting the victim's name and identifying information when stopped by law enforcement authorities or charged with a crime.

- The Identity Theft and Assumption Deterrence Act of 1998, which made identity theft itself a crime, designated the FTC as the central storehouse for identity theft complaints.

- About one in six identity theft victims said the thief used their personal information to open at least one new account, such as new credit card account, new loan or other new account.

- ID theft victims are young. Over half of identity theft victims are under age 40. Only 11 percent of victims are age 60 or older.

- According to the Social Security Administration Inspector General's analysis of

the SSA's Fraud Hotline data, more than 80 percent of SSN misuse allegations were related to identity theft.

- On average, identity thieves misused victims' information for about three months. However, when the identity thief opens new accounts with the victim's information, the misuse lasts longer—more than one out of four of these victimizations lasted six months or more.

Despite the FTC's best efforts, there is no single database in the U.S. that captures all investigations and prosecutions of identity theft cases. Enforcement actions on identity theft law may be undercounted. Because identity theft is usually committed to facilitate another crime, criminals often are charged with those other crimes like bank, wire or mail fraud rather than with identity theft.

HOW THEY STEAL

There are so many ways for someone to steal your identity. Only about one in 100 identity thieves is ever caught. Think of all the people who hold they key to your identity via your Social Security number alone: your banks; credit card companies; credit bureaus; insurance companies; brokerage houses; doctors' offices; dental offices; phone companies; cable companies; fitness gym; local rec center; public library; school; baseball league; tennis club; DMV; department and specialty stores (e.g., Bloomingdale's, Victoria's Secret, Eddie Bauer) where you purchase items regularly with their card; apartment building manager; subscriptions

that track subscribers by their SSNs; airline frequent flyer programs...and all those Internet sites you've joined using your SSN as an identifier or username.

ID THEFT RED FLAGS

- **Mail**: Your mailbox—filled with incoming or outgoing mail—is an easy target. A thief can look through the mail for bills or bank statements and pilfer the information. Check washing is another method; a thief can wash out the ink on a signed check, change the amount and rewrite the check to himself. Watch out for those pre-approved credit cards that come in the mail, too.

- **Fraudulent change of address**: A thief can fill out a change-of-address form at the post office so the mail and bills are redirected to the thief's address or mail drop.

- **Trash cans and dumpsters**: Business and building dumpsters are attractive items to thieves looking for discarded letters with business and customer account information. A thief can disguise himself as a homeless person digging through garbage.

- **Onlookers**: Whenever you expose your ATM or calling card in a public place, someone might be looking. Criminals lurk around ATM machines and public phones in high-traffic areas for victims.

They might even look from afar with the help of binoculars, camcorders or a zooming camera.

- **Lost or stolen purse or wallet**: If a thief comes across a lost purse or wallet, or steals it himself, he'll have a lot of personal information to use. This is when keeping certain things like your Social Security card and health insurance card (which often bears your SSN) out of your purse is key.

- **Inside jobs**: An employee of a business might illegally retrieve information that a business has collected for legitimate reasons. An entry-level employee at a financial institution, for example, might be able to access others' personal information, and sell it to identity thieves.

- **Internet**: Computer-savvy criminals use the Internet to hunt down victims. Personal Web pages are targets, and genealogical databases give thieves access to maiden names, which are often used as passwords to bank accounts and the like.

- **Skimmers**: Skimmers are small devices that can read the magnetized strip from a credit card, bank card for account numbers, balances and verification codes. Thieves using skimmers often get temporary work within restaurants, hotels and retail stores where they capture and retain the information from the card you hand over when making a purchase. First your card is run through the regular

THE PERSONAL SECURITY HANDBOOK

credit-card reader, then through the skimmer without you knowing.

- **Pretexting**: You might be duped into giving up your personal information over the phone with someone who disguises himself as a representative with a reliable company that you use, like your phone company, local department store or cable company.

Due to the nature of identity theft (how easy it is to commit when no one is looking), preventing identity theft starts with the consumer. Even when law enforcement agencies catch up to addressing the problem, it will still be up to you to prevent the majority of the crimes.

Because ID thieves are opportunistic, some basic preventive measures can do a lot to dissuade. Prevention starts with deterrence, much like using an alarm or The Club on your car. Either of these antitheft devices can be surpassed, but real deterrence comes from making your car a little tougher to steal…so that the thief will move on to the next one.

> The world is too large, transactions are too quick and easy to make, and the volume of information passed back and forth is too dense for anyone to prevent all ID theft. Accept ID theft as a negative by-product of our modern technology—like spam, computer viruses and other nuisances that get traded when you swap security for convenience.

There are two other big burdens you must come to accept:

1) It's up to you to safeguard your personal information; and

2) It's up to you to report any illegal activity to the proper authorities and agencies. Unfortunately, no one is going to call you the minute someone starts opening accounts or making large purchases in your name.

No one is going to save your reputation and credit history when it runs amok and requires time, money and energy to repair it. No one can afford to have the "It can't happen to me" mentality. There is no one preventive tactic that guarantees you won't become a victim of identity theft. But when the tactics are all used together, they will lower your overall risk.

Preventing ID Theft

☐ Ask your employer to dispose of sensitive, personal information and to secure anything that cannot be destroyed.

☐ Ask your employer to control access to sensitive, personal information...and to limit the use of your Social Security number in the workplace.

☐ Buy a personal shredder and use it to shred bank and credit-card statements, cancelled checks and pre-approved offers before throwing away.

- ☐ Secure your mailbox with a locking mechanism or use a door with a mail slot.

- ☐ Avoid leaving outgoing checks or paid bills in your residential mailbox. Take all mail to the post office or nearest U.S. Mailbox. Consider paying bills electronically.

- ☐ Check your credit report annually with Experian, TransUnion or Equifax) and look for address changes and fraudulent accounts.

- ☐ Pick up re-ordered checks at your bank instead of having them mailed to you.

- ☐ Notify your credit card company if your card has expired and you have not yet received a replacement.

- ☐ Clean your wallet out of excess information. Do not carry your Social Security card.

- ☐ Check your bills carefully. Look for discrepancies between your receipts and statements. Open bills promptly and report anything unchecked quickly.

- ☐ When making purchases with a credit card in public, keep your eyes on your card, try to keep the numbers facing down, and get it back as soon as possible.

- ☐ Keep a record of your credit card information in a safe place.

☐ Limit amount of information on the Internet, including your home page or sites that detail family genealogy.

☐ Don't give out personal information over the phone unless you initiated the call and know who you are calling.

PUBLIC RECORDS

Records have always been available for the public to view on microfilm rolls at the courthouse, but some new laws make those records even more accessible online. Keep in mind:

- **Title companies** can research deeds from their office computers;

- Homeowners can look into a lien or judgment without going to the courthouse;

- Public access to **electronic records** will continue to broaden;

- It's up to you to know what public records contain information about you, and whether those documents can get into anyone's hands; and

- Many counties are not diligent in **separating public from confidential documents** in their computer databases. Until courts adopt policies that comply with the rules, there's no telling what will end up on the Internet.

> If you've ever bought or sold a piece of property, served in the military or been involved in a court judgment, a valuable piece of your identity could soon find its way onto the Internet: Your Social Security number. Voter registration cards and marriage certificates can also contain such information.

You can't prevent local courts from posting information. But you can check these postings online for any references to you. And—since most courts honor requests to edit or obscure personal details—you can ask them to cut out your detailed information. (This cutting is sometimes called *redicting*.)

- Never provide your SSN, or any other personal information for that matter, when it's not necessary. Product manufacturers don't need to know your occupation. The health club does not need your SSN. Only the government or a lender should be asking for Social Security numbers. Never have your Social Security number printed on your checks—you can write it in if necessary

- Some states have laws that say Social Security numbers may not be openly displayed on things like health forms, bank account records or anything sent in the mail.

- Many people have been duped by swindlers who pretend to be from the IRS. When someone claims to work for the

Internal Revenue Service and starts firing sensitive questions at you, do a little homework before answering.

- Be wary of first-time calls or surprise visits from someone you've never heard from before. If the IRS needs to conduct business with you (e.g., you've underpaid in taxes), you should receive a letter from the IRS before hearing directly from an agent.

The best way to handle an alleged IRS agent: Pass the trouble on to a tax adviser, such as a lawyer, accountant or "enrolled agent," a tax professional licensed to represent you when you face the IRS. If you're still not satisfied by the investigator's credentials, or have some reasonable basis for your suspicions, call (800) 366-4484. Or write to: Treasury Inspector General for Tax Administration, PO Box 589, Ben Franklin Station, Washington D.C. 20044-0589. TIGTA says the information you provide is kept confidential, and you may remain anonymous.

WHAT'S IN YOUR WALLET?

As previously mentioned, if you're still schlepping around with your Social Security card in your wallet, remove it and put it in a safe place at home.

If you were to lose your wallet today, would you know exactly what was in it?

- Place the contents of your wallet on a photocopy machine. Copy both sides of

each license, credit card, etc. This way you will know what you had in your wallet should it get lost or stolen. You will have all of the account numbers and phone numbers to call and cancel. Keep the photocopy in a safe place.

- Along with leaving out your SSN, dump bank account numbers, personal identification numbers (PINs), passports and birth certificates. Leave those in a fireproof box at home—never in your wallet.

- Don't carry more blank checks than you need in your wallet, either. If your SSN is on your driver's license, ask your state for a new number and license (if possible).

Quick Tips

☐ Never leave your purse or wallet unattended in public or in open view in your car or shopping cart.

☐ Keep checks in a secure place and destroy them when you close a checking account.

☐ Never give credit card, bank or Social Security information over the telephone.

☐ Minimize exposure of your Social Security number.

- ☐ Safeguard your credit, debit and ATM card receipts and shred them before disposing of them.

- ☐ Check your utility and subscription bills to make sure the charges are yours.

- ☐ Memorize your passwords and personal identification numbers and don't keep them near your credit cards.

- ☐ Keep a list of, or copy, all credit and identification cards you carry so you can quickly call the issuers to inform them about missing or stolen cards. But keep this list in a safe place where no one can find and steal it.

- ☐ A form to stop credit and insurance offers from being sent to you is available at www.ag.state.mi.us.

- ☐ A form to remove your name from telephone and mailing lists is available at www.dmaconsumers.org/privacy.html.

REVIEWING CREDIT REPORTS

Review your credit reports from each of the three national credit reporting agencies at least twice a year. You are entitled to a free copy of your credit report if you are unemployed, on welfare, were recently denied credit or if your report is inaccurate because of fraud. (Otherwise, there is a small fee.) In addition to your debts and payment history, credit reporting agencies also provide: general data (name, SSN, mari-

tal status, addresses—past and present); employer's name and address; inquiries of your credit file; and public record information like bankruptcies and liens.

Credit reporting agencies do not, however, maintain files regarding your race, religion, medical history or criminal record—if you have one.

Review your report carefully to make sure no unauthorized charges were made on your existing accounts and that no fraudulent accounts or loans were established in your name.

Unfortunately, credit agencies and their credit scores respond slowly to remedy credit rating effects of ID theft. This is where most of the lasting damage happens.

Below, you'll find the information you need to access all three major credit bureaus.

The consolidation among banks and other financial institutions that followed the Gramm-Leach Bliley Act in the early 2000s has brought attention to the critical role that credit bureaus (CRAs, in the jargon of the law) play in financial services. As a result, the CRAs have started to adjust their businesses to serve end-users more directly. That means you.

The Big Three Credit Bureaus

Equifax (*www.equifax.com*)

- To dispute information in your report, write: Equifax Service Center, Attn: Dispute Department, P.O. Box 740256, Atlanta, GA 30374.

- To order a credit report, call: (800) 685-1111; or write: P.O. Box 470241, Atlanta, GA 30374, Attn: Disclosure Department.

- To remove your name from pre-approved offers of credit and marketing lists, call: (888) 567-8688; or write: Equifax Options, P.O. Box 740123, Atlanta, GA 30374-0123.

Experian (*www.experian.com*)

- To order a credit report, call: (888) 397-3742; or write: P.O. Box 9066, Allen, TX 75013.

- To dispute information in your report, call: (800) 493-1058; or write: P.O. Box 9556, Allen, TX 75013.

- To remove your name from pre-approved offers of credit cards, call: (800) 567-8688. To remove your name from marketing lists, call: (800) 407-1088.

TransUnion (*www.tuc.com*)

- To order a credit report, call: (800) 916-8800; or write: Trans Union LLC, Consumer Disclosure Center, P.O. Box 1000, Chester, PA 19022.

- To dispute information in your report, call: (800) 916-8800.

- To have your name removed from pre-approved offers of credit and marketing lists, call: (888) 567-8688; or write to: Trans Union LLC's Name Removal Option, P.O. Box 97328, Jackson, MS 39288-7328.

When your ID has been stolen, your overall goals as a victim of identity theft are to:

- Close fraudulent accounts;

- Clear yourself of responsibility for any debts or other criminal activities the thief has perpetrated in your name;

- Ensure that your credit report is correct; and

- Find out as much information about the suspect as you can so you can share that information with the police and the FTC.

Specifically:

- **Contact the fraud department** at each of the above three credit bureaus. Inform them of the basis of your concern and ask them to "flag" your file. A flagged file means creditors will have to get your approval before any new account is opened in your name or a change is made to an account. Confirm your conversation in writing by sending a letter to each credit bureau stating whom

you spoke to, when, what was discussed and any promises of follow-up action made by you. Make copies of your letters and send copies; keep originals. Send via registered or certified mail with return receipt requested. Keep a log of your conversations and retain copies of all correspondence.

- **Obtain a copy of your credit report** from each of three agencies. Review each report for peculiar activity; close any account that has been opened in your name and that you did not authorize.

- Seek legal council if you have a problem getting creditors or credit reporting agencies to remove fraudulent entries.

- Contact creditors for accounts that have been tarnished or opened fraudulently. Speak to the security or fraud investigations department, and follow-up with a letter in writing. **Close compromised accounts** and stop payment, if necessary. Use different personal identification numbers (PINs) and passwords to open a new account.

- Notify your bank(s) of the theft. Cancel your checking and savings account, opening new ones with new numbers and passwords, etc. **Obtain new ATM cards** with new passwords. Ask the bank to issue you a secret password that must be used in every transaction. Put stop payments out on any outstanding checks that you are unsure of.

- **Report stolen checks and fraudulent bank activity** to Telecheck and National Processing Company (NPC). These companies will flag your file so that checks will be turned down at retail outlets. Call Telecheck at (800) 366-2425. Call NPC at (800) 526-5380.

- Notify the Social Security Administration's Office of the Inspector General if your Social Security Number has been used fraudulently. If your number has become associated with bad checks and credit, you may want to have your number changed...but this should only be considered during extreme situations.

- Notify the Passport Office to be on the lookout for anyone ordering a new passport fraudulently.

- Call your telephone, electric, gas and water companies and warn them that someone might attempt to open new service using your identification.

- File a complaint with the police where the theft took place.

- File a complaint with the U.S. Postal Service if personal mail was stolen or a change of address was sent in your name.

- Contact the Federal Trade Commission (FTC) to get information and guidance.

- Obtain **copies of all complaints, letters and correspondence**. Keep meticu-

lous logs of your conversations and correspondence, including dates and names.

- Be polite but persistent when pursuing the clean-up. Discuss your situation with trusted friends and perhaps seek the advice and support from a counselor or victim rights organization.

Contacting your local Consumer Credit Counseling Service office might expedite removal of fraudulent claims from your credit report. Call (800) 388-2227. Remember: If you are denied credit, you are entitled to a free credit report. Although the Secret Service has jurisdiction over financial fraud cases, it's hard for an individual to get the federal agency's attention unless the dollar amount is significant. If you want their attention, ask someone in the fraud department of your credit card companies and/or banks to notify the particular Secret Service agent with whom they work.

INSURANCE FOR ID THEFT

Cleaning up after an identity thief can be time consuming...and costly. Now that the problem has become so bad, companies are responding by offering **insurance to ease the burden**. ID theft is one of the few crimes where victims not only have to prove they've been harmed, but they have to reclaim their stolen identity. This can take months or years, and during that time it's extremely hard to apply for credit of any kind.

- ID theft insurance is a new niche in the insurance industry.

- Check your current policies for existing coverage. A homeowners or renters policy might already contain some coverage. One company's policy, for example, covers identity theft expenses up to $25,000 at no extra charge through its homeowners or renters insurance.

- ID theft coverage pays for the time and money it takes you to complete the logistical and legal paperwork. This can include lost wages, notary public, Federal Express or other kinds of packaging and mailing. In some instances, legal expenses can be covered.

- If you want coverage, ask your current insurance company for information about adding coverage to existing policies, or if you need to purchase a stand alone policy. Travelers insurance, for example, sells stand alone policies from $59 to $180 a year.

- You might also be able to find coverage through your credit card companies, bank or employer. An employer can purchase coverage under a legal insurance policy and you pay the premiums out of your paycheck.

Having coverage for ID theft won't protect you from the problem in the first place. It will only help you once it has happened.

When shopping for this kind of insurance, look for:

1) price;

2) content (what expense will be covered); and

3) overlay (whether you already have coverage elsewhere).

You can visit the Insurance Information Institute's Web site at *www.iii.org* for more information about the insurance companies that provide policies for this problem.

CREDIT MONITORING SERVICES

Insurance companies also have been partnering with credit management and monitoring agencies to provide new services to consumers—but at a cost. For example, ING Direct gives customers, among other things, online access to weekly credit reports using Equifax credit data, weekly updated credit scores and personalized tips to improve your credit.

These services can cost between $30 to more than $100 a year. Equifax has teamed up with the insurer American International Group (AIG) to offer specialized insurance. Equifax's Credit Watch product promises to send alerts to consumers via e-mail or letter within 24 hours after something pops up on their credit report. The company will also reimburse you up to $2,500 in identity theft costs.

> **The same companies that record your credit histories and market your good name and reputation also sell services so you can protect your credit.**

It's important that you make sure that the monitoring service you choose or try out **delivers data in a useful format.** You shouldn't have to pay to have your credit reports monitored, but until legislation changes the mechanics behind reporting, marketing and monitoring people's credit reports, you have to decide how much you're willing to pay for services. Be wary of how these programs are promoted: many offer "free" services of one month, then will gladly charge you $80 for the year if you forget to call and cancel.

Some Final Tips

☐ Don't give your checking account number to people you don't know, even if they claim they are from your bank.

☐ Reveal checking account information only to businesses you know to be reputable.

☐ Report lost or stolen checks immediately.

☐ Properly store or dispose of cancelled checks and guard new checks.

☐ Report any inquiries or suspicious behavior to your banker who will take measures to protect your account and notify proper authorities.

☐ Do not leave your automated teller machine receipt at the ATM; it contains account information.

☐ Check your bank statements carefully and often.

☐ Use direct deposit (if possible).

CONCLUSION

A lot of identity theft prevention has to do with **making lifestyle changes**. It's about how you manage your mail, financial records and bank accounts, pay bills, use your credit cards, use the Internet...and even pick topics of conversation at a cocktail party.

A lot of surviving identity theft has to do with being organized, making a lot of phone calls and being aggressive at cleaning up the mess.

Identity theft has emerged as a consequence to our technology and the conveniences we've come to appreciate in our daily living. In the Chapter 4, we talked about computing problems—and mentioned how easy an identity theft can occur as a result of using computers and shopping online. It's so easy these days to be duped by a nagging telemarketer when we're trying to make dinner and do a million tasks at once.

The best advice: Never give out your personal information over the phone...or over e-mail for that matter, unless you can be assured that you're dealing with a legitimate person.

Ask for correspondence in writing, and always confirm your contact if possible. Now that thieves can impersonate your cable company representative, phone company representative or even an Internet-based company like eBay, it's easy to fall prey when you least expect it.

For more detailed information about identity theft, see Silver Lake Publishing's book *Identity Theft: How to Protect Your Name, Your Credit and Your Vital Information…and What to Do When Someone Hijacks Any of These.*

CHAPTER 6

DISASTER
PREPARATION

A disaster can strike at any moment, threatening your life, your family and your home. With some disasters, like hurricanes and blizzards, you can receive some warnings or alerts that the weather is conducive for a disaster. But with others, like earthquakes or blackouts, you might not know about the impending disaster until it **strikes suddenly** and catches everyone off-guard. At that point, you won't be the only one in need of help—and you won't be the first one on the list to get help. What would you do if basic services—water, gas, electricity or telephones—were cut off for an indefinite time period? Local officials and relief workers will be on the scene after a disaster, but they cannot reach everyone right away.

Four Steps for Disaster Prep

1) Learn What Could Happen to You

2) Create a Disaster Plan

3) Conduct a Home Hazard Hunt

4) Practice and Maintain the Plan

LEARN WHAT COULD HAPPEN

- Contact your local Red Cross chapter or emergency management office to inquire about potential disasters in your area. Gather information. Take notes. Ask about how to prepare for each type of potential disaster.

- Learn about your **community's warning signals**. Does your community sound off warning signals? If so, what do they mean and who do they sound like? What do you do in response to these signals?

- Ask about animal care after a disaster. Health regulations prohibit animals from entering emergency shelters, so you'll need to know what to do with your pets.

- Ask about help for the elderly or disabled. You might need to assist someone in your family or your next door neighbor.

- Know what kinds of disaster plans are in place at your workplace, in your children's schools or day care centers and other places where your family spends time. If no plans exist, consider volunteering to help create one.

CREATE A DISASTER PLAN

Meet with your family and discuss why you need to prepare for disaster. Talk about the possible disasters

that could strike and what everyone needs to do to share responsibilities and work together as a team. Go through the evacuation process step by step.

Disaster Plan Checklist

☐ If you have a car, keep at least a **half tank of gas** in it at all times in case you need to evacuate.

☐ Become familiar with alternate routes and other means of transportation out of your area.

☐ If you do not have a car, plan how you will leave if you have to.

☐ Plan how you will assemble your family and anticipate where you will go. Choose several destinations in different directions so you have options in an emergency.

☐ Pick **two places to meet**:

1) Right outside your home in case of a sudden emergency, like a fire; or

2) A place outside your neighborhood in case you can't get back. Everyone must know the address and phone number.

☐ Dedicate an out-of-state friend to be your "**family contact**." After a disaster, it's often easier to call long distance than local. Other family members should call this person and tell them where they are. Everyone must know your contact's phone number.

CONDUCT A HOME HAZARD HUNT

Look for things in your home that can cause injury or more damage in the event of a disaster. Ordinary items that can move, fall, break or cause a fire must be taken into account.

Home Hazard Checklist

☐ Repair defective electrical wiring and leaky gas connections.

☐ Fasten shelves securely.

☐ Place large, heavy objects on lower shelves.

☐ Hang pictures and mirrors away from beds.

☐ Brace overhead light fixtures.

☐ Secure water heater. Strap to wall studs.

☐ Repair cracks in ceilings or foundations.

☐ Store weed killers, pesticides and flammable products away from heat sources.

☐ Place oily polishing rags or waste in covered metal cans.

☐ Clean and repair chimneys, flue pipes, vent connectors and gas vents.

☐ Post emergency telephone numbers by phones (fire, police, ambulance, etc.).

☐ Teach children and household occupants (i.e., housekeepers, nannies, etc.) how and

when to call 911 or your local emergency number for help.

- ☐ Show each family member how and when to turn off the utilities (water, gas and electricity) at the main switches. Keep necessary tools by these valves.

- ☐ Check if you have adequate insurance coverage.

- ☐ Get training from the fire department for each family member on how to use the fire extinguisher (ABC type), and show them where it's kept.

- ☐ Install smoke detectors on each level of your home, especially near bedrooms. If a bedroom sits atop a garage, think about installing a CO detector that can measure the level of carbon monoxide leaking from the garage.

- ☐ Stock emergency supplies and assemble a Disaster Supplies Kit (see page 117).

- ☐ Take a Red Cross first-aid and CPR class. These courses are offered year-round at local offices. Community rec centers and colleges will also offer classes.

- ☐ Determine the best escape routes from your home. Find two ways out of each room, as well as the safest places in your home for each type of disaster. Teach every member of the household how to use these escape routes and safety zones. Everyone should know under what circumstances they need to use these locales.

PRACTICE & MAINTAIN THE PLAN

- Quiz your kids every six months or so.

- Conduct fire and emergency evacuations.

- Replace stored water and stored food every six months.

- Test and recharge your fire extinguisher(s) according to manufacturer's instructions.

- Test your smoke detectors monthly and change the batteries at least once a year.

Working with neighbors can save lives and property. Meet with your neighbors to plan how the neighborhood could work together after a disaster until help arrives. If you're a member of a neighborhood organization, such as a home association or crime watch group, introduce disaster preparedness as a new activity. Know your neighbors' special skills (e.g., medical, technical) and consider how you could help neighbors who have special needs, such as disabled and elderly persons. Make plans for child care in case parents can't get home.

When Disaster Strikes

☐ Remain calm and patient. Focus on putting your plan into action.

☐ Check for injuries; give first-aid and get help for seriously injured people.

☐ Listen to your battery-powered radio for news and instructions

☐ Check for damage in your home:

• Use flashlights. Do not light matches or turn on electrical switches, if you suspect damage.

• Sniff for gas leaks, starting at the water heater. If you smell gas or suspect a leak, turn off the main gas valve, open windows and get everyone outside quickly.

• Shut off any other damaged utilities. (You will need a professional to turn gas back on.)

• Clean up spilled medicines, bleaches, gasoline and other flammable liquids immediately.

☐ Check on your neighbors, especially elderly or disabled persons.

☐ Make sure you have an adequate water supply in case service is cut off.

☐ Stay away from downed power lines.

IF YOU'RE IN A VEHICLE

• If there is an explosion or other factor that makes it difficult to control the vehicle, pull over, stop the car and set the parking brake.

• If the emergency could impact the physical stability of the roadway, avoid over-

passes, bridges, power lines, signs and other hazards.

- If a power line falls on your car, you are at risk of electrical shock. Stay inside until a trained person removes the wire.

- Listen to the radio for information and instructions as they become available.

AN EXPLOSION AT WORK

- Take shelter against your desk or a sturdy table.

- Exit the building ASAP.

- Check for fire and other hazards.

- Take your emergency supply kit if time allows.

- Follow instructions from any official.

A FIRE AT WORK

- Exit the building quickly.

- Crawl low if there is smoke

- Use a wet cloth, if possible, to cover your nose and mouth.

- Use the back of your hand to feel the upper, lower and middle parts of closed doors.

- If the door is not hot, brace yourself against it and open slowly.

on-prescription drugs

inch sterile roller bandages (3 rolls)

inch sterile roller bandages (3 rolls)

issors

eezers

edle

oistened towelettes

tiseptic

ermometer

ngue blades (2)

be of petroleum jelly or other lubri-
t

n-Prescription Drugs

virin or nonaspirin pain reliever

ti-diarrhea medication

acid (for stomach upset)

up of Ipecac (to induce vomiting if
ised)

ative

ivated charcoal (use if advised by
on Control Center)

Supplies

s kits, or paper cups, plates and plas-
tensils

- If the door is hot, do not open it. Look for another way out.

- Do not use elevators.

- If you catch fire, do not run. Stop, drop and roll to put out the fire.

- If you are at home, go to a previously designated meeting place.

- Account for your family members and carefully supervise small children.

- Never go back into a burning building.

IF YOU'RE TRAPPED IN DEBRIS

- If possible, use a flashlight to signal your location to rescuers.

- Avoid unnecessary movement so that you don't kick up dust.

- Cover your nose and mouth with anything you have on hand. (Dense-weave cotton material can act as a good filter. Try to breathe through the material.)

- Tap on a pipe or wall so that rescuers can hear where you are.

- If possible, use a whistle to signal rescuers.

- Shout only as a last resort. Shouting can cause a person to inhale dangerous amounts of dust.

DISASTER SUPPLY KIT

There are **six basics you need** in the event of an emergency: water, food, first-aid supplies, clothing and bedding, tools and emergency supplies and other special items. Keep the items that you would most likely need during an evacuation in an easy-to-carry container. A big plastic container that can be sealed up, a camping backpack or a large duffle bag that closes are good things for storing these items:

Water

- ☐ Store water in plastic containers such as soft drink bottles. Avoid using containers that will decompose or break, such as milk cartons or glass bottles. A normally active person needs to drink at least two quarts of water each day. Hot environments and intense physical activity can double that amount. Children, nursing mothers and ill people will need more.

- ☐ Store one gallon of water per person per day.

- ☐ Keep at least a three-day supply of water per person (two quarts for drinking, two quarts for each person in your household for food preparation/sanitation).

Food

Store at least a **three-day supply of non-perishable food.** Select foods that require no refrigeration, preparation or cooking and little or no water. If you must heat food, pack a can of sterno. Select food

items that are compact an
lection of the following
ply Kit:

- ☐ Ready-to-eat ca
 vegetables
- ☐ Canned juices
- ☐ Staples (salt, su
- ☐ High energy f
- ☐ Vitamins
- ☐ Food for infa
- ☐ Comfort/str
- ☐ First-Aid Kit

**Assemble a first-ai
each car.**

First-Aid

- ☐ Sterile adh
- ☐ Assorted
- ☐ Cleansing
- ☐ Latex glo
- ☐ Sunscree
- ☐ 2-inch st
- ☐ 4-inch s
- ☐ Triangu

- ☐
- ☐
- ☐
- ☐
- ☐
- ☐
- ☐

- ☐
- ☐
- ☐
- ☐
- ☐ S
 a
- ☐ L
- ☐ A
 p

Tools and

- ☐ M
 tic

- ☐ Emergency preparedness manual
- ☐ Battery-operated radio and extra batteries
- ☐ Flashlight and extra batteries
- ☐ Cash or traveler's checks, change
- ☐ Non-electric can opener, utility knife
- ☐ Fire extinguisher: small canister ABC type
- ☐ Tube tent
- ☐ Pliers
- ☐ Tape
- ☐ Compass
- ☐ Matches in a waterproof container
- ☐ Aluminum foil
- ☐ Plastic storage containers
- ☐ Signal flare
- ☐ Paper, pencil
- ☐ Needles, thread
- ☐ Medicine dropper
- ☐ Shut-off wrench, to turn off household gas and water
- ☐ Whistle
- ☐ Plastic sheeting
- ☐ Map of the area (for locating shelters)

Sanitation

- ☐ Toilet paper, towelettes
- ☐ Soap, liquid detergent
- ☐ Feminine supplies
- ☐ Personal hygiene items
- ☐ Plastic garbage bags, ties (for personal sanitation uses)
- ☐ Plastic bucket with tight lid
- ☐ Disinfectant
- ☐ Household chlorine bleach
- ☐ Clothing and Bedding

Include at least one complete change of clothing and footwear per person.

- ☐ Sturdy shoes or work boots, socks
- ☐ Rain gear
- ☐ Blankets or sleeping bags
- ☐ Hat and gloves
- ☐ Thermal underwear
- ☐ Sunglasses

SPECIAL ITEMS

Remember family members with special requirements, such as infants and elderly or disabled persons.

For Baby

- ☐ Formula
- ☐ Diapers
- ☐ Bottles
- ☐ Powdered milk
- ☐ Medications

For Adults

- ☐ Heart and lood pressure medication
- ☐ Insulin
- ☐ Prescription drugs
- ☐ Denture supplies
- ☐ Contact lenses and supplies
- ☐ Extra eye glasses
- ☐ Entertainment
- ☐ Games and books

Important Family Documents

- ☐ Will, insurance policies, contracts deeds, stocks and bonds

- ☐ Passports, Social Security Cards, immunization records
- ☐ Bank account numbers
- ☐ Credit card account numbers and companies
- ☐ Inventory of valuable household goods
- ☐ Important telephone numbers
- ☐ Family records (birth, marriage, death certificates)

Store your kit in a convenient place known to all family members. Keep smaller versions of the supplies kit in other locations, like your car, your workplace or the garage.

Keep items in airtight plastic bags. Change your stored water supply every six months so it stays fresh. Replace your stored food every six months. Re-think your kit and family needs at least once a year. Replace batteries, update clothes, etc.

Ask your physician or pharmacist about storing prescription medications.

> You don't need to have gas masks on hand. Not only would each gas mask have to be fitted to every face, but they offer a false sense of security. Neither do you need to stock up on antibiotics. If and when you would need an antibiotic for exposure to an organism, you'll be able to obtain the proper medi-

cation. Storing antibiotics before a threat opens the door to misuse and abuse. Only keep them if your physician has prescribed them for specific conditions. In that case, know how to store and maintain antibiotics, as well as how to use them.

Although potassium iodide (KI) has been shown to provide some limited help in preventing the body from absorbing certain types of radioactive particles that could inhibit metabolism through action of the thyroid gland, the Centers for Disease Control does not recommend stocking up or take KI in advance of an attack.

KI is only useful for certain types of radioactivity and can also be harmful if used improperly, by children or by people with chronic or undiagnosed thyroid disease. Consult your physician if you have questions about this chemical.

SHOULD YOU STAY OR GO?

Determining when you should evacuate your home in the event of an emergency can be easy...*and* hard. You might have emergency officials telling you to get out while your first instinct is to protect your home and everything in it. You see this a lot on television when there's a major brush fire and entire communities must be evacuated—yet there's always a few who decide to stay and try to save their homes and possessions. This isn't the best thing to do.

Steps to Take

☐ Listen to the emergency officials and heed their advice. If they tell you to go, you should do as they say and follow their orders. Instructions will be given over the radio and television. Safe shelters will open if an evacuation is ordered.

☐ If you're specifically told to evacuate or seek medical treatment, do so immediately.

☐ Be careful not to confuse an evacuation shelter with a room in a home or building that is selected to be sealed up and used as a "shelter-in-place." If you are told to shelter-in-place, you should be in a place that will afford you protection from a contaminant in the air (see the next page for more about how to build such a shelter).

☐ Have at least three days' worth of supplies in case stores are closed and roads are impassible due to a disaster like a flood or winter storm.

☐ Store enough supplies for your pet's needs for at least three days, including food, water and related items such as kitty litter.

☐ Use common sense and available information to determine if there is immediate danger. If you cannot get public information, it's up to you to determine if it's best to stay inside or risk uncertainty

outside. There are other circumstances when staying put and creating a barrier between yourself and potentially contaminated air outside—a process known as "shelter-in-place"—is essential.

☐ Use available information to assess the situation. If you see large amounts of debris in the air, or if local authorities say the air is badly contaminated, you may want to take this kind of action.

IF YOUR KIDS ARE IN SCHOOL

Schools have emergency plans; know what your children's school plans are before a disaster strikes.

- Schools often will hold children after a disaster has struck until the area is safe and parents or a designated adult can pick them up.

- Do not drive to school to pick up children unless advised to do so; driving on the roadways may put you in harm's way.

SHELTER-IN-PLACE

Instead of evacuating an area, you might be instructed to shelter-in-place, in which case you'll go into your designated spot where you can **seek shelter from a contaminant** in the air.

If a weapon of mass destruction has hit close to you, local government authorities might advise people to shelter-in-place. Once you do, it's important to have supplies on hand to get you through the period when it's critical to remain inside. Think panic room or bomb shelter.

Tips to Follow When You Shelter-in-Place

- ☐ Bring your family and pets inside.

- ☐ Lock doors, close windows, air vents and fireplace dampers.

- ☐ Turn off fans, air conditioning and forced air heating systems.

- ☐ Take your emergency supply kit unless you have reason to believe it has been contaminated.

- ☐ Go into an interior room with few windows, if possible.

- ☐ Seal all windows, doors and air vents with plastic sheeting and duct tape. Consider measuring and cutting the sheeting in advance to save time.

- ☐ Be prepared to improvise and use what you have on hand to seal gaps so that you create a barrier between yourself and any contamination.

- ☐ Have a radio or small TV on hand to watch news from local officials.

Duct tape and plastic sheeting are required for sealing yourself into a room. You'll need one roll of duct tape and durable plastic sheeting that can cover over vents and other openings to the outside. The goal is to create a barrier to air flow from the outside to the inside. You won't suffocate during the short period of time you'll need to remain in this room. A shelter-in-place is not intended to be used for weeks.

A bathroom may be a good choice for the shelter-in-place as long as it does not have windows (or few windows) and you can block openings (such as vents) to the outside.

A "safe room," as defined by the Federal Emergency Management Agency, is a room—preferably below ground—in which people can take shelter from a tornado. If that room is below ground, it may *not* be the safest choice if you are told to stay at home and "shelter-in-place" during a weapons of mass destruction event due to the possibility that some contaminants may seep into rooms below ground level.

You should have a "safe room" if you live where tornadoes are a threat. But don't confuse a "safe room" used for protection from windstorms with a room selected for "shelter-in-place." They are technically different, although they serve a similar purpose. If a "safe room" for windstorms is above ground level and has no windows, it can also be an ideal location in which to shelter-in-place.

BUILDING SHELTERS

A shelter should be a place where you and your family can survive a tornado or hurricane with little or no injury. In hurricane-prone areas, the shelter cannot be built where it can be flooded during a hurricane. Your shelter should be **readily accessible from all parts of your house**, and it should be free of clutter. During extreme windstorms, the shelter must be adequately anchored to the house foundation to resist overturning and uplift. The connections between all parts of the shelter must be strong enough to resist failure, and the walls, roof and door must resist penetration by windborne missiles.

Designing a building to resist damage from more than one natural hazard requires different, sometimes competing, approaches. Building a structure on an elevated foundation to raise it above expected flood levels can increase its vulnerability to wind and seismic damage. In flood-prone areas, careful attention should be given to the warning time, velocity, depth and duration of floodwaters. These flooding characteristics can have a significant bearing on the design and possibly even the viability of a shelter. Your local building official or licensed professional engineer or architect can provide you with information about other natural hazards that affect your area and can recommend appropriate designs.

Size: The size of your shelter will depend on the type of disaster you are protecting yourself from. Tornadoes don't last long, so if you are relying on your shelter only for tornado protection, comfort is not of great concern. A shelter that provides about five square feet of floor area per person will be big enough.

A shelter for hurricanes, however, might need to house you and your family for a longer period of time—up 12 hours, for example. For this type of shelter, the recommended amount of floor area per person is about 10 square feet. Necessities, such as water and toilet facilities, should be provided. If you plan to build a shelter with any wall longer than eight feet, consult a licensed professional engineer or architect.

Foundation Types: Houses on a basement, slab-on-grade or crawlspace are suitable for the installation of a shelter.

Basement Shelters

- Build an entirely separate structure with the basement's walls or use one or more of the basement walls as walls of the shelter.

- If you use the basement walls, they will have to be specially reinforced. Typical reinforcement techniques used in residential basement walls will not provide sufficient protection from missiles. In new construction, your builder/contractor can reinforce the walls near the shelter during the construction of your house. Reinforcing the basement walls of an existing house is not practical.

The likelihood of missiles entering the basement is lower than for above ground areas; however, there is a significant chance that missiles or falling debris will enter the basement through an opening left when a window, door or the first floor has been torn off by extreme wind. Your basement shelter must have

> its own reinforced ceiling; the basement ceiling (the first floor above) cannot be used as the ceiling of the shelter.

- A lean-to shelter is the cheapest kind of shelter that can be built in a basement. It's built in the corner of the basement and uses two basement walls.

In general, it's easier to add a basement shelter during the construction of a new house than to retrofit the basement of an existing house. If you plan to add a basement shelter as a retrofitting project, keep the following points in mind:

- You must be able to clear out an area of the basement large enough for the shelter.

- Unless the exterior basement walls contain steel reinforcement, these walls cannot be used as shelter walls since they are not reinforced to resist damage from missiles and uplift from extreme winds.

- Exterior basement walls that are used as shelter walls must not contain windows, doors or other openings.

Slab-on-Grade Houses

- A slab-on-grade house is built on a concrete slab that is installed on compacted or natural soil. The concrete may be reinforced with steel that helps prevent cracking and bending.

- To install a concrete or concrete masonry shelter in a new home, your contractor must make the slab thicker where the shelter will be built. The thickened slab will act as a footing beneath the walls of the shelter to provide structural support. It will also anchor the shelter so that it stays in place during an extreme wind event, even if the rest of the house is destroyed.

- Because building a shelter with concrete or masonry walls in an existing slab-on-grade house is not practical, a wood-frame shelter can be created from an existing room, such as a bathroom or closet, or built as a new room in an open area, such as a garage.

- You can also build a shelter as an addition to the outside of a slab-on-grade house. This type of shelter must have not only proper footings but also a watertight roof. Because a shelter built as an outside addition will be more susceptible to the impact of missiles, it should not be built of wood framing. Instead, it should be built of concrete or concrete masonry. Access to this type of shelter can be provided through an existing door or window in an exterior wall of the house.

If You Retrofit a Slab-on-Grade House

- The walls of the shelter must be completely separate from the structure of the house.

- Keeping the walls separate makes it possible for the shelter to remain standing even if portions of the house around it are destroyed by extreme winds.

If you are creating your shelter by modifying a bathroom, closet or other interior room with wood-frame walls, the existing walls— including sheathing on either the inside or outside of the walls, such as drywall or plaster—must be removed and replaced with walls and a ceiling resistant to the impact of windborne missiles and other effects of extreme winds.

If you build a shelter with concrete or concrete masonry walls, a section of your existing slab floor will have to be removed and replaced with a thicker slab. Again, this is usually not practical in an existing house.

Crawlspace

A house built on a crawlspace usually has a floor constructed of wood framing. Along its perimeter, the floor is supported by the exterior foundation walls. The interior part of the floor is supported by beams that rest on a foundation wall or individual piers.

Crawlspace foundation walls may be concrete, but are usually constructed of concrete masonry. Crawlspace foundation walls are often unreinforced and therefore provide little resistance to the stresses caused by extreme winds.

> It's harder to build a shelter inside a house built on a crawlspace foundation than a house built on a basement or slab-on-grade. Why? The entire shelter, including its floor, must be separate from the framing of the house.

A shelter built inside the house cannot use the floor of the house. The shelter must have a separate concrete slab floor installed on top of earth fill and must be supported by concrete or concrete masonry foundation walls. An economical alternative: build an exterior shelter on a slab-on-grade adjacent to an outside wall of the house and provide access through a door installed in that wall.

Maintaining ventilation in the area below the floor of the house is key. The wood-framed floor of a house on a crawlspace foundation is typically 18 to 30 inches above the ground by the foundation walls. The space below the floor is designed to allow air to flow through so that the floor framing will not become too damp. Installation of the shelter cannot block this air flow.

The shelter must have a separate foundation. Building the foundation inside the house would require cutting out a section of the existing floor and installing new foundation members, fill dirt and a new slab...a complicated and expensive operation.

An economical alternative to building a shelter in a house with a crawlspace foundation: Build an exterior shelter, made of concrete or concrete masonry, on a slab-on-grade foundation adjacent to an outside wall of the house.

SMALLPOX, RICIN , ETC.

There's a lot of information available to address the concern over biological and chemical weapons. Al-

though Chapter 10 of this book will deal with some specifics, you can get more information online at the Centers for Disease Control (*www.cdc.gov*) and at the U.S. government's Health and Human Services' site (*www.hhs.gov*).

A biological attack is caused by an organism like a virus (e.g., influenza, Ebola) or bacteria (e.g., smallpox, botulin), whereas a chemical attack is caused by a chemical agent like ricin or mustard gas.

Generally, chemical attacks have the potential to make many people sick quickly; but the chemical dies out—often just as quickly.

Biological attacks, on the other hand, tend to be subtle, more pernicious and more destructive due to a **biological agent's longevity**. The **incubation periods** for many biological germs are days to weeks—not minutes to hours.

Ricin, for example, is a potent toxin that has potential to be used as an agent of biological warfare and as a **weapon of mass destruction** (WMD). It's widely available, easily produced and derived from the beans of the castor plant (*Ricinus communis*). It can be disseminated as an aerosol, by injection or as a food and water contaminant.

There is no treatment or vaccine for exposure to ricin, but it doesn't last long as a destructive agent.

CONCLUSION

Disaster preparation relies on two things:

1) Being **ready for sudden disaster** with supplies and know-how; and

2) **Responding to disaster** in a methodical and un-panicked manner.

Both of these tasks are difficult. First, people usually don't like to prepare for the what-ifs and as such, they delay those plans and don't stock up on supplies. (Picture the looks of the supermarket shelves prior to the arrival of a hurricane or blizzard; everyone rushes out for supplies at the last minute.)

Second, avoiding panic and anxiety during a disaster—when people around you are freaking out—is an added challenge.

(Some of the information in this chapter was adapted from the *Family Disaster Plan* developed by the Federal Emergency Management Agency and the American Red Cross. It is public information.)

This chapter gave you the tools for the first task—preparing for disaster. We continue our discussion on disasters by taking a closer look in the next two chapters at specific disasters and how to survive them.

DISASTER MANAGEMENT

Financial losses from earthquakes concern Americans with good reason: the Northridge earthquake in 1994 caused an estimated $20 billion in damage.

But losses of human life resulting from an earthquake are less frequent in the U.S. and other industrialized nations than in less developed countries.

Most losses of life in an earthquake occur when **structures collapse**. Because construction standards of developed countries are superior to those of the third world, buildings in the developed world are more likely to remain intact.

For example: In 1990, an earthquake with a magnitude of 7.7 occurred in Iran killing over 40,000 people; the late 2003 quake in Bam, Iran that measured 6.8 killed more than 30,000 people and destroyed 70 percent of the buildings. On the other hand, a 1983 earthquake of the same magnitude in Japan (a more densely populated country) killed only 107.

EARTHQUAKE BASICS

Earthquakes can cause buildings and bridges to collapse, telephone and power lines to fall, and result in fires, explosions and landslides. They can also cause huge ocean waves, called tsunamis, which travel long distances over water until they crash into coastal areas.

In the U.S., people have more than just sturdy construction to protect them from earthquakes. They can also buy **insurance** designed especially for that purpose.

Standard property insurance does not cover losses caused by an earthquake—but earthquake coverage for the residence, other structures and personal property may be attached by endorsement.

Several earthquake-prone states—most notably California—require any insurance company that writes homeowners coverage to write earthquake coverage. This doesn't mean these companies have to *publicize* earthquake coverage. Most stay quiet about it. But they have to give you information, if you ask.

Separate earthquake coverage can be expensive—sometimes as much as the underlying basic homeowners coverage.

The type of construction of the structure is a significant factor in earthquake rates. Different rates apply to **frame buildings** (wood or stucco-covered wood structures) and to those classified as **masonry** (brick, stone, adobe or concrete block).

> For earthquake coverage, masonry rates are usually higher than frame rates. For ordinary property coverages, the reverse is true—masonry rates are lower than frame rates. This situation exists because of the nature of the exposure: wooden buildings are more vulnerable to fire than stone or brick buildings are; but stone or brick buildings are more vulnerable to earthquakes than wooden buildings are.

Because it's so expensive, earthquake insurance is usually sold with high deductibles—making it, appropriately, a **catastrophic coverage**. Anything short of major damage to your house won't be covered.

> Earthquakes are ongoing disasters. They require some even-tempered management. If you have substantial damage to your home, including exposure to outdoor weather, your insurance company will expect you to seal it off—so rain will not cause more damage.

The best strategy for buying earthquake insurance is to take the coverage with a deductible equal to 20 to 50 percent of the cost of rebuilding. That will keep the premiums low—and, if things get shaken up, you can usually get a FEMA loan for the deductible.

This is the opposite of the best plan for flood insurance—which is, simply, buy as much of the subsidized FEMA coverage as the Feds will sell you. In-

surance companies will often try to classify any damage caused by water—which often comes after an earthquake—as "flood-related" and, therefore, not covered. This can be an issue on which you have to press hard for your rights.

ALTERNATIVES TO INSURANCE

If you don't have earthquake insurance and suffer substantial losses when the Big One hits, you can claim a so-called "casualty loss" on your taxes—but only if you have unreimbursed damage in excess of 10 percent of your annual income plus $100. So, if you earn $50,000 a year, you can write off damages only in excess of $5,100.

Once an area has been officially designated a federal disaster area in the wake of an earthquake, FEMA and other agencies make various forms of **low-interest and no-interest loans** available for rebuilding. Many people simply count on these subsidized loans as their earthquake insurance.

In California, some homeowners may qualify for a so-called "mini-policy" offered directly from the state through its **California Earthquake Authority**. The advantage of the mini-policy is that it's cheap; the disadvantage is that it doesn't offer as much coverage as an endorsement from your insurance company.

SURVEYING THE HOME

Look for items in your home that could become a hazard in an earthquake:

- ☐ Repair defective electrical wiring, leaky gas lines and inflexible utility connections (fires that follow earthquakes often result from leaky gas lines).

- ☐ Bolt down water heaters and gas appliances (have a gas shut-off device installed that's triggered by an earthquake).

- ☐ Place large or heavy objects on lower shelves. Fasten shelves to walls. Brace high and top-heavy objects.

- ☐ Store bottled foods, glass, china and other breakables on low shelves or in cabinets that can fasten shut.

- ☐ Anchor overhead lighting fixtures.

- ☐ Check and repair deep plaster cracks in ceilings and foundations.

- ☐ Check that the foundation is firmly anchored.

- ☐ Install flexible pipe fittings to avoid gas or water leaks. Flexible fittings are more resistant to breakage.

- ☐ Know where and how to shut off electricity, gas and water at main switches and valves. Check with your local utilities for instructions.

- ☐ Hold earthquake drills with your family:

- • **Locate safe spots** in each room under against an inside wall. Reinforce this information by physically placing yourself and your family in these locations.

- **Identify danger zones** in each room (near windows where glass can shatter, bookcases or furniture that can fall over or ceiling fixtures that could fall down).

- Develop a **plan for reuniting your family** after an earthquake. This is when following your disaster plan comes into play. You must be ready to live on your own for at least three days.

- Review your insurance policies. Some damage may be covered even without specific earthquake insurance. Protect important home and business papers.

DURING AN EARTHQUAKE

Once the shaking begins, stay inside until the shaking stops and it's safe to go outside. Most injuries during earthquakes occur when people are hit by falling objects when entering or exiting buildings. The following is a list of helpful reminders for when you find yourself in an earthquake:

- Drop, cover and hold on. Minimize your movements during an earthquake to a few steps to a nearby safe place. Stay indoors until the shaking has stopped and you are sure exiting is safe.

- If you are indoors, take **cover under a sturdy desk**, table or bench, or against an inside wall, and hold on. Stay away from glass, windows, outside doors or walls and anything that could fall, such as

CHAPTER 7: DISASTER MANAGEMENT

lighting fixtures or furniture. If you are in bed, stay there, hold on and protect your head with a pillow, unless you are under a heavy light fixture that could fall.

- If there isn't a table or desk near you, cover your face and head with your arms and crouch in an inside corner of the building. **Doorways** should only be used for shelter if they are in close proximity to you and if you know that it is a strongly supported load-bearing doorway (a main entryway or front door).

- Remain outdoors if you are already there. Move away from buildings, streetlights and utility wires.

- Avoid all elevators.

> **If you're in a moving vehicle when you feel an earthquake, stop as quickly as safety permits and remain in the vehicle. Avoid stopping near or under buildings, overpasses or utility wires. Then, proceed cautiously, watching for road and bridge damage.**

If you are indoors, stay indoors until the shaking has stopped and you are sure exiting is safe.

AFTER AN EARTHQUAKE

Beware of aftershocks. These secondary shock waves are usually less violent than the main quake but can be

THE PERSONAL SECURITY HANDBOOK

strong enough to do additional damage to weakened structures. Some suggestions:

- **Check for injuries.** Do not move seriously injured persons unless they are in immediate danger of death or further injury. If you must move an unconscious person, first stabilize the neck and back, then call for help.

- If the electricity goes out, use flashlights or battery powered lanterns. **Do not use candles, matches or open flames indoors** after the earthquake because of possible gas leaks.

- Wear sturdy shoes in areas covered with fallen debris and broken glass.

- Check your home for structural damage. If you have any doubts about safety, **have your home inspected** by a professional before entering.

- Check chimneys for visual damage; however, have a professional inspect the chimney for internal damage before lighting a fire.

- Clean up spilled medicines, bleaches, gasoline and other flammable liquids. Evacuate the building if gasoline fumes are detected and the building is not well ventilated.

- Visually inspect utility lines and appliances for damage.

If you smell gas or hear a hissing or blowing sound, open a window and leave. Shut off the main gas valve, if you know where it is. Report the leak to the gas company from the nearest working phone or cell phone available. Stay out of the building.

- Switch off electrical power at the main fuse box or circuit breaker if electrical damage is suspected or known.

- Shut off the water supply at the main valve if water pipes are damaged.

- Do not flush toilets until you know that sewage lines are intact.

- Open cabinets cautiously. Beware of objects that can fall off shelves.

- Use the phone only to report life-threatening emergencies.

- **Stay off the streets**. If you must go out, watch for fallen objects, downed electrical wires, weakened walls, bridges, roads and sidewalks.

- Stay away from damaged areas unless your assistance has been specifically requested by police or fire fighters.

- If you live in a coastal area, be aware of possible tsunamis, sometimes mistakenly called tidal waves. When local authorities issue a tsunami warning, assume that a series of dangerous waves is on the way. **Stay away from the beach.**

LANDSLIDES AND MUD FLOWS

Landslides occur when masses of rock, earth or debris move down a slope. They can move at slow or very high speeds and be activated by storms, earthquakes, volcanic eruptions, fires and by human modification of the land.

Debris and mud flows are rivers of rock, earth and other debris saturated with water. They develop when water rapidly accumulates in the ground, during heavy rainfall or rapid snowmelt, changing the earth into a flowing river of mud or "slurry." They can flow rapidly down slopes or through channels, and can strike with little warning at avalanche speeds. They can also travel several miles from their source, growing in size as they pick up trees, cars and other objects.

Land mismanagement can also cause these disasters. Even in ritzy areas like the Malibu area in Southern California experiences problems when the rains come. Land-use zoning, professional inspections and proper design can minimize the threat.

Things to Keep in Mind

- ☐ Consult hiring an expert for advice on your home's risk of being in the path of a landslide or mud/debris flow.

- ☐ Minimize home hazards by planting ground cover on slopes and building retaining walls.

☐ Observe the patterns of storm drainage on slopes and especially the places where runoff water converges. Watch for any sign of land movement—such as small slides, flows or progressively leaning trees—on the hillsides near your home.

☐ Recognize the **warning signs**:

- Doors or windows stick or jam for the first time.

- New cracks appear in plaster, tile, brick or foundations.

- Outside walls, walks, or stairs begin pulling away from the building.

- Slowly developing, widening cracks appear on the ground or on paved areas such as streets or driveways.

- Underground utility lines break.

- Water breaks through the ground surface in new locations.

- Fences, retaining walls, utility poles or trees tilt or move.

- You hear a faint rumbling sound that increases in volume as the landslide nears.

- The ground slopes downward in one specific direction and may begin shifting in that direction under your feet.

After the disaster, check for damage and report any downed power lines or utilities. Seek the **advice of a geotechnical expert** for evaluating landslide hazards

or designing corrective techniques to reduce landslide risk. A professional will be able to advise you of the best ways to prevent or reduce landslide risk, without creating further hazard.

RISING WATER

Floods are the most common natural disaster. They occur so often that most are not declared disasters by the president—and, therefore, victims don't get federal financial assistance.

If you live near a flood zone, your home has a 1 percent chance each year of being flooded. One percent seems low, but it's not.

> Only 20 percent of Americans who live in flood zones have flood insurance, and the percentage of people living elsewhere is substantially lower. One third of all flood claims come from outside high-risk areas.

So, how do you get flood coverage? The easiest way is to go through the **National Flood Insurance Program (NFIP)**, which is part of the Federal Emergency Management Agency (FEMA).

The NFIP requires you to apply for flood coverage at least 30 days in advance. You cannot watch the weather report and then expect to have a policy effective at midnight. You are probably more at risk for flooding than you think.

You may not near the flood plains of the Mississippi River, but severe snow, overflowing rivers, heavy rains (*El Niño*), levy or dam failures can cause flooding. If your community does not participate in the NFIP, ask an insurance company or agent what you can do to get coverage.

Pre-Flood Precautions

☐ Make a record of your personal property. Take photographs or videotapes of your belongings. Store these documents in a safe place.

☐ Keep insurance policies, deeds, property records and other important papers in a safe place away from your home.

☐ Avoid building in a floodplain unless you elevate and reinforce your home.

☐ Elevate furnace, water heater and electric panel to higher floors or the attic if they are susceptible to flooding.

☐ Install "check valves" in sewer traps to prevent flood water from backing up into the drains of your home.

☐ Construct barriers such as levees, berms and floodwalls to stop floodwater from entering the building.

☐ Seal walls in basements with **waterproofing compounds** to avoid seepage.

☐ Call your local building and safety department for more information.

If there's any possibility of a flash flood, move immediately to higher ground. Do not wait for instructions to move. During a flood:

- Listen to **radio or television stations** for local information.

- Be aware of streams, drainage channels, canyons and other areas known to flood suddenly. Flash floods can occur in these areas with or without such typical warning signs as rain clouds or heavy rain.

If local authorities issue a flood watch, prepare to evacuate and conduct the following:

- Secure your home. If you have time, tie down or bring outdoor equipment and lawn furniture inside. Move essential items to the upper floors.

- If instructed, **turn off utilities** at the main switches or valves. Disconnect electrical appliances. Do not touch electrical equipment if you are wet or standing in water.

- Fill the bathtub with water in case water becomes contaminated or services are cut off. Before filling the tub, sterilize it with a diluted bleach solution.

If you are evacuating, do not drive into flooded areas. Six inches of water will reach the bottom of most passenger cars causing loss of control and possible stalling. A foot of water will float many vehicles. Two feet of water will wash away almost all vehicles. If floodwaters rise around your car, abandon the car and move to higher ground, if you can do so safely.

You and your vehicle can be quickly swept away as floodwaters rise. After a flood has occurred:

- Avoid floodwaters. The water may be contaminated by oil, gasoline or raw sewage. The water may also be charged from underground or downed power lines.

- Avoid walking through moving water. If you must walk in a flooded area, walk where the water is not moving.

- Be wary of areas where floodwaters have receded. Roads may have weakened and could collapse under a car.

- Stay away from **downed power lines** and report them to the power company.

- Return home only when authorities indicate it is safe. Stay out of buildings if surrounded by floodwaters. Use caution entering buildings. There may be hidden damage, particularly in foundations.

Remember, flood waters are *dirty*. Many people get sick after floods because of hygiene problems. So, keep these points in mind:

- **Wash hands frequently** with soap and clean water if you come in contact with floodwaters.

- Discard food that has come in contact with floodwaters.

- Listen for news reports to learn whether the community's water supply is safe to drink.

- Service damaged septic tanks, cesspools, pits and leaching systems as soon as possible. Damaged sewage systems are serious health hazards.

Finally, a few general rules apply:

- Establish the **condition of your belongings** and your home via photos or videotape.

- Separate damaged and undamaged belongings.

- Locate your financial records.

- Keep detailed records of clean-up costs.

- Seek local guidance for repairing your flooded home. The American Red Cross can help you with this process.

HURRICANES

A hurricane is a type of tropical cyclone, a low-pressure system that generally forms in ocean water around the equator. Generally, hurricanes occur during a season that starts in the later Summer and goes through the Fall. In the 2004 hurricane season, the southeastern U.S. was hit with **four major storms**—an unusually high number that caused unusually heavy damage.

Tropical cyclones are classified as: **tropical depressions** (an organized system of clouds and thunderstorms with a defined surface circulation and maximum sustained winds of 38 m.p.h. or less); **tropical storms** (an organized system of thunderstorms with

a defined surface circulation and maximum sustained winds of 39 to 73 m.p.h.; or **hurricanes** (a system of strong thunderstorms with maximum sustained winds of 74 m.p.h. or higher).

All Atlantic and Gulf of Mexico coastal areas are subject to hurricanes or tropical storms. Although rarely struck by hurricanes, parts of the Southwest United States and the Pacific Coast experience heavy rains and floods each year from hurricanes spawned off Mexico. The Atlantic hurricane season lasts from June to November with the peak season from mid-August to late October.

Hurricanes are classified according to the Saffir-Simpson intensity scale, which makes distinctions based on peak wind velocity.

Saffir-Simpson Hurricane Intensity Scale

- Category 1 Winds of 74 to 95 m.p.h. Minimal damage.

- Category 2 Winds of 96 to 110 m.p.h. Moderate damage.

- Category 3 Winds of 111 to 130 m.p.h. Extensive damage.

- Category 4 Winds of 131 to 155 m.p.h. Extreme damage.

- Category 5 Winds of 156 m.p.h. and up. Catastrophic damage.

Hurricanes make the news when they pop up on the radar and start heading toward populated areas. Before Hurricane Andrew hit southern Florida in 1992, insurance experts didn't think that insured losses from a hurricane could exceed $8 billion. They were wrong. Andrew's collision with the area just south of Miami led to some $15.5 billion in insurance claims.

When **Hurricane Isabel** grew to a Category 5, out in the Atlantic in September 2003, communities along southeastern Atlantic coasts braced for the hurricane's arrival nearly a week in advance. Days before Isabel's estimated arrival, several communities had already evacuated. Weather reports can now track and predict the strength of hurricanes five days in advance, whereas 15 years ago an accurate warning came within three days. You have more time to prepare these days than you did before.

Hurricanes do damage in two ways. They kick up **vicious winds** that can toss around cars, trees and anything else that is above ground. They also bring a lot of water with them—both in the form of rain and the so-called "**storm surge**," extremely high tides that usually occur to the north and east of the storm.

Most people can protect their houses or apartments from the wind by covering windows with plywood or masking tape. And by moving anything under 100 pounds indoors. The water damage is harder to prevent. You can move valuables up—to high shelves or second floors. But rain can seep into a house from all points.

Hurricanes can cause catastrophic damage to coast-lines and several hundred miles inland. They can also spawn tornadoes and microbursts, create surge along the coast and cause extensive damage due to inland flooding from trapped water.

A *storm surge* is a huge dome of water pushed on-shore by hurricane and tropical storm winds. Storm surges can reach 25 feet high and be 50 to 100 miles wide. *Storm tide* is a combination of the storm surge and the normal tide (a 15-foot storm surge plus a 2-foot normal high tide creates a 17-foot storm tide). These phenomena cause severe erosion and extensive damage to coastal areas.

Despite improved warnings and a decrease in the loss of life, property damage continues to rise be-cause an increasing number of people are living or vacationing near coastlines.

"WATCHES" AND "WARNINGS"

- **Hurricane/Tropical Storm Watch**: Hurricane/tropical storm conditions are possible in the specified area, usually within 36 hours.

- **Hurricane/Tropical Storm Warning**: Hurricane/tropical storm conditions are expected in the specified area, usually within 24 hours.

- **Short Term Watches and Warnings**: These warnings provide detailed information on specific hurricane threats, such as flash floods and tornadoes.

Once a hurricane watch or warning has been declared, consider the following:

☐ Secure your home. Close storm shutters. **Secure outdoor objects or bring them indoors**. Moor your boat.

☐ Water systems may become contaminated or damaged; so, fill the bathtub for a supply of safe of water in case you're unable or told not to evacuate.

☐ If you are evacuating, take your disaster supply kit with you to the shelter. Remember that alcoholic beverages and weapons are prohibited within shelters. Also, pets are not allowed in a public shelter due to health reasons.

☐ Prepare to evacuate. Fuel your car—gas stations may be closed after the storm. If you do not have a car, make arrangements for transportation with a friend or relative. Review evacuation routes. If instructed, turn off utilities at the main valves. Evacuate to an inland location, if:

- local authorities announce an evacuation and you live in an evacuation zone;

- you live in a mobile home or temporary structure;

- you live in a high-rise. Hurricane winds are stronger at higher elevations;

- you live on the coast, on a floodplain near a river or inland waterway; or

- you feel you are in danger.

When Authorities Order an Evacuation

☐ Leave immediately.

☐ Follow evacuation routes announced by local officials.

☐ Stay away from coastal areas, riverbanks and streams.

☐ Tell others where you are going.

☐ Turn off utilities if told to do so by authorities.

☐ If not instructed to turn off, turn the refrigerator to its coldest setting and keep closed.

☐ Turn off propane tanks.

☐ In strong winds, follow these rules:

- Take refuge in a small interior room, closet or hallway.

- Close all interior doors. Secure and brace external doors.

- In a two-story residence, go to an interior first-floor room, such as a bathroom or closet.

- In a multiple-story building, go to the first or second floors and stay in interior rooms away from windows.

- Lie on the floor under a table or another sturdy object.

- Avoid using the phone except for serious emergencies. Local authorities need first priority on telephone lines.

If you are not required or are unable to evacuate, stay indoors during the hurricane and away from windows and glass doors. Keep curtains and blinds closed. Do not be fooled if there is a lull, it could be the eye (the dead center) of the storm—winds will pick up again.

After a hurricane, stay where you are if you are in a safe location until local authorities say it is safe to leave. If you evacuated the community, **do not return to the area until authorities say it is safe to return.**

Keep tuned to local radio or television stations for information about caring for your household, where to find medical help, how to apply for financial assistance, etc.

Do not drive on flooded or barricaded roads or bridges. Closed roads are for your protection. Remember: As little as six inches of water may cause you to lose control of your vehicle—two feet of water will carry most cars away.

THUNDERSTORMS

Although thunderstorms are small when compared to hurricanes and blizzards, **all thunderstorms are dangerous**. Thunderstorm produce lightning and there are many associated dangers to thunderstorms: tornadoes, strong winds, hail and flash floods.

> **Flash flooding is responsible for more fatalities— more than 140 annually—than any other thunder- storm-associated hazard.**

The Western United States experience **dry thunder- storms** sometimes. These are storms that produce lightning but don't have rain that reaches the ground. Because the air beneath the clouds is so dry, the falling rain evaporates quickly. Dry thunderstorms are a com- mon cause of wildfires.

> **Thunderstorms can occur singly, in clusters or in lines. Some of the most severe weather occurs when a single thunderstorm affects one location for an extended time. They can produce heavy rain for a brief period, anywhere from 30 minutes to an hour.**

Of the estimated 100,000 thunderstorms each year in the United States, about 10 percent are classified as severe. A severe thunderstorm produces hail at least three-quarters of an inch in diameter, has winds of 58 miles per hour or higher, or produces a tornado.

Safety tips related to thunderstorms:

- If you count the number of seconds between a flash of lightning and the next clap of thunder, then divide that number by 5, you can determine the distance to the lightning in miles.

- **Remove dead or rotting trees** and branches that could fall and cause injury or damage during a severe thunderstorm.

- When a thunderstorm approaches, secure outdoor objects that could blow away or cause damage. Shutter windows, if possible, and secure outside doors. If shutters are not available, close window blinds, shades, or curtains.

DEALING WITH LIGHTNING

In the United States, an average of 300 people are injured and 80 people are killed each year by lightning. Although most lightning victims survive, people struck by lightning often report a variety of **long-term, debilitating symptoms**, including memory loss, attention deficits, sleep disorders, numbness, dizziness, stiffness in joints, muscle spasms and depression. When thunderstorms threaten your area, get inside a home, building or hard top automobile (not a convertible) and stay away from metallic objects and fixtures. If you are inside a home:

- Avoid showering or bathing. Plumbing and bathroom fixtures can conduct electricity.

- Avoid using a corded telephone, except for emergencies. Cordless and cellular telephones are safe to use.

- Unplug appliances and other electrical items such as computers and turn off air conditioners. Power surges from lightning can cause serious damage.

If you are stuck outside with **no time to reach a safe location**:

- In a forest, seek shelter in a low area under a thick growth of small trees.

- In open areas, go to a low place such as a ravine or valley. Be alert for flash floods.

- Do not stand under a natural lightning rod, such as a tall, isolated tree in an open area.

- Do not stand on a hilltop, in an open field, on the beach or in a boat on the water.

- Avoid isolated sheds or other small structures in open areas.

- Get away from open water. If you are boating or swimming, get to land and find shelter immediately.

- Get away from anything metal—tractors, farm equipment, motorcycles, golf carts, golf clubs and bicycles.

- Stay away from wire fences, clotheslines, metal pipes, rails and other metallic paths that could carry lightning to you from some distance away.

If you feel your **hair stand on end** (which indicates that lightning is about to strike), squat low to the ground on the balls of your feet. Place your hands over your ears and your head between your knees. Make yourself the smallest target possible and minimize your contact with the ground. *Do not* lie flat on the ground.

According to the National Oceanic and Atmospheric Association, your chances of being struck by lightning in your lifetime are estimated to be 1 in 600,000. They can be even less, if you follow these safety tips:

- Postpone outdoor activities if thunderstorms are likely.

- Remember the 30/30 lightning safety rule: Go indoors if, after seeing lighting, you cannot count to 30 before hearing thunder. Stay indoors for 30 minutes after hearing the last clap of thunder.

- Rubber-soled shoes and rubber tires provide *no* protection from lightning. However, the steel frame of a hard-topped vehicle provides increased protection if you are not touching metal. Although you may be injured if lightning strikes your car, you are much safer inside a vehicle than outside.

TORNADOES

In *The Wizard of Oz*, Dorothy managed to land herself in a munchkin-paradise after getting in the middle of a tornado. But that's not how it works in real life.

Tornadoes are nature's most violent storms. Spawned from powerful thunderstorms, tornadoes can uproot trees, destroy buildings and turn harmless objects into deadly missiles. They can devastate a neighborhood in seconds. And they can kill without warning.

A tornado appears as a **rotating, funnel-shaped cloud** that extends to the ground with whirling winds that can reach 300 miles per hour. Damage paths can be in excess of one mile wide and 50 miles long.

- Tornadoes might appear nearly transparent until they pick up dust and debris or a cloud forms in the funnel. The average tornado **moves SW to NE** but tornadoes have been known to move in any direction.

- The average forward speed is 30 m.p.h. but may vary from stationary to 70 m.p.h. with rotating winds that can reach 300 miles per hour.

- Tornadoes are most frequently reported east of the Rocky Mountains during spring and summer months but can occur in any state at any time of year.

- In the southern states, peak tornado season is March through May, while peak months in the northern states are during the late spring and early summer.

- Tornadoes are most likely to occur between 3 P.M. and 9 P.M., but can occur at any time of the day or night.

Before a Tornado Strikes

☐ Determine **places to seek shelter**, such as a basement or storm cellar. If an underground shelter is not available, identify an interior room or hallway on the lowest floor.

☐ Practice going to your shelter with your household.

☐ Know the locations of designated shelters in places where you and your household spend time, such as public buildings, nursing homes and shopping centers. Ask local officials whether a registered engineer or architect has inspected your children's schools for shelter space.

☐ Ask your local emergency manager or American Red Cross chapter if there are any **public safe rooms or shelters** nearby.

☐ Assemble a disaster supply kit.

☐ Make a record of your personal property. Take photographs or videotapes of your belongings. Store these documents in a safe place.

DURING A TORNADO WATCH

Some tornadoes are clearly visible, while rain or nearby low-hanging clouds obscure others. Occasionally, tornadoes develop so rapidly that little, if any, advance warning is possible. Before a tornado hits, the wind may die down and the air may become very still. A

cloud of debris can mark the location of a tornado even if a funnel is not visible. In the event of a tornado watch:

- Be alert for approaching storms. If you see any revolving funnel shaped clouds, report them by telephone to your local police department or sheriff's office.

- Watch for **tornado danger signs**: Dark, often greenish sky; large hail; a large, dark, low-lying cloud (particularly if rotating); loud roar, similar to a freight train.

- Tornadoes generally occur **near the trailing edge** of a thunderstorm. It is not uncommon to see clear, sunlit skies behind a tornado. Avoid places with wide-span roofs such as auditoriums, cafeterias, large hallways, supermarkets or shopping malls.

- Be prepared to take shelter immediately. Gather household members and pets. Assemble supplies to take to the shelter such as flashlight, battery-powered radio, water, and first-aid kit.

If There Is a Tornado Warning

☐ Immediately find your shelter once a tornado has been sighted.

☐ In a residence or small building, move to a designated shelter—such as a basement, storm cellar or safe room.

☐ If there is no basement, go to an interior room on the lower level (closets, interior hallways). Put as many walls as possible between you and the outside. Get under a sturdy table and use your arms to protect your head and neck. Stay there until the danger has passed.

☐ Do not open windows. Stay away from windows, doors and outside walls. Go to the **center of the room**. Stay away from corners because they attract debris.

☐ In a school, nursing home, hospital, factory or shopping center, go to predetermined shelter areas. Interior hallways on the lowest floor are usually safest. Stay away from windows and open spaces.

☐ In a high-rise building, go to a small, interior room or hallway on the **lowest floor possible**.

☐ Get out of vehicles, trailers and mobile homes immediately and go to the lowest floor of a nearby building or a storm shelter. Mobile homes, even if tied down, offer little protection from tornadoes.

☐ If caught outside with no shelter, lie flat in a nearby ditch or depression and cover your head with your hands. Be aware of potential for flooding.

☐ Do not get under an overpass or bridge. You are safer in a low, flat location.

☐ Never try to outrun a tornado in urban or congested areas in a car or truck; in-

stead, **leave the vehicle immediately for safe shelter**. Tornadoes are erratic and move swiftly.

☐ Watch out for flying debris. Flying debris from tornadoes causes most fatalities and injuries.

After a tornado has occurred:

• Beware of broken glass and downed power lines.

• Use caution when entering a damaged building. Be sure that walls, ceilings and roofs are in place and that the structure rests firmly on the foundation. Wear work boots and gloves.

• Check for injuries. Do not move seriously injured persons unless they are in immediate danger of death or further injury. If you must move an unconscious person, first **stabilize the neck and back**, then call for help.

FIRE

Fire is the most common disaster—and it can happen anywhere. Each year more than 4,000 Americans die and more than 25,000 are injured in fires, many of which could be prevented. Direct property loss due to fires is estimated at $8.6 billion annually.

Heat and smoke from fire can be more dangerous than the flames. Inhaling the super-hot air can sear your lungs. Fire produces poisonous gases that make

you disoriented and drowsy. Instead of being awakened by a fire, you may fall into a deeper sleep.

Fire insurance is one of the oldest coverages offered by insurers. It is readily available and usually at reasonable cost or as part of a standard homeowners policy. Smoke damage to your home's interior and contents from a sudden and accidental fire is covered and so is water damage resulting from fire fighting activity. Although homeowners insurance does not cover earthquake and flood losses, fire losses caused by earthquakes or floods (such as an explosion and fire from a ruptured gas line or shorted electrical appliance) are covered.

How to Prevent a Fire

☐ Install **smoke alarms** in every room. Test them regularly.

☐ Make sure windows are not nailed or painted shut.

☐ If you have bars on your windows, make sure the fire-safety openings work.

☐ Plan **two escape routes**.

☐ Consider escape ladders for upper floors.

☐ Teach family members to stay low to the floor (where the air is safer) when escaping a fire.

☐ Check electrical wiring and heating elements in your home.

☐ Don't let trash and junk that can burn accumulate.

☐ Never use gasoline, benzine, naptha or similar liquids indoors.

☐ Keep flammables, matches and lighters away from children.

☐ Avoid smoking in bed, or when drowsy or medicated.

☐ Extinguish all matches and cigarettes with water.

☐ Install **A-B-C type fire extinguishers** in the home and teach family members how to use them.

☐ Consider installing automatic fire sprinklers.

WHEN THERE'S A FIRE

In the event of a fire, attempt to put out a fire you can control with water or a fire extinguisher.

Never use water on an electrical fire; use only a fire extinguisher approved for electrical fires. Smother oil and grease fires in the kitchen with baking soda or salt, or put a lid over the flame if it is burning in a pan. Do not attempt to take the pan outside.

Other points:

- If you catch on fire, **Stop, Drop** and **Roll**. Don't run; it make the fire burn faster.

- If you try to escape through a closed door, touch the top of the door with the back of your hand before you open it. Crawl if the room on the other side is smoke-filled. The air is clearer and cooler near the floor.

- If you cannot escape, hang a white or light-colored sheet outside the window to alert fire fighters of your presence.

- Close doors behind you as you escape.

Things to Do After a Fire

☐ Keep records of clean-up and repair costs. You will need receipts for insurance and income tax claims. Don't throw away damaged goods until you've inventoried everything.

☐ Secure personal belongings or move them to another location.

☐ **Discard food, beverages and medicine that were exposed** to heat, smoke or soot. If anything thawed in the freezer, be sure to discard that, too.

☐ If you have a safe that survived the fire, do not open it until it has had time to cool. Fire-safe boxes can hold intense heat for hours; if you open it before it has cooled, the contents can burst into flames.

WILDFIRES

The Southern California wildfires of 2003 alerted many homeowners who live in remote, brush-filled areas to the dangers inherent to their location and landscape. Most were not prepared to flee their homes and gather their most prized possessions in minutes. To prepare for wildfires in your area:

- Ask your local fire department about the potential for wildfires in your area.

- Be **prepared in advance to evacuate your home**. This means knowing what you have to take…and what to leave behind. Paperwork—insurance policies, birth certificates, titles, deeds, Social Security cards and other documents—may be more vital to your life than things like appliances or clothing.

- Make your property fire resistant by keeping your lawn trimmed, leaves raked and the roof and rain-gutters debris-free. Stack firewood at least 30 feet away from your home.

- Create defensible space by thinning trees and brush within 30 feet around your home. Beyond 30 feet, remove dead wood, debris and low tree branches.

- Landscape your property with **fire-resistant plants and vegetation**. Succulents—cactus, yucca, ice plant and related plants—are fire resistant. Hardwood trees resist fire more than pine, evergreen, eucalyptus and fir trees.

- Keep water sources—hydrants, ponds, swimming pools and wells—accessible to the fire department.

THE PERSONAL SECURITY HANDBOOK

- Use fire-resistant material in the construction of a home. Materials like stone, brick and metal resist fire better than wood.

- Cover exterior vents and eaves with metal mesh screens to prevent debris from collecting and to help keep sparks out.

Despite the predictable pattern of wildfire, homeowners continue to build in areas exposed to uncontrollable fire hazards. Why? Unlike other catastrophic risks, the risk of **fire is covered** under a standard homeowners contract.

CONCLUSION

If there's one thing you cannot afford to have when it comes to disaster planning, it's the "It can't happen to me" mentality. Having this mentality will cost lives and millions of dollars.

This chapter discussed some of the natural disasters you might face. But, keep in mind, that man-made disasters are probably a larger threat to people living in cities and high-density areas. We'll consider *those* risks in the next few chapters.

SAFE TRAVELS

As we've mentioned before, the two risk factors you can control are the **things you do** and the **places you go**. Your travel habits affect your exposure to higher risks; those habits include how you travel (method of transportation), where you travel, what you do when you get there, how you behave, what you bring with you or take away and how you react to certain situations you might encounter.

This chapter gives you an array of tools for dealing with travel risks, whether you're traveling for work or are on vacation with your family. Because most travelers don't worry too much about traveling within the U.S., we'll concentrate on general tips for **traveling to foreign countries** and abroad. But these strategies and tips can work just about anywhere.

Although the U.S. federal government has made improvements to the travel and security industries since 9/11—most notably by the creation of the Department of Homeland Security—a great majority of guarding your security and safety relies on you, your wits and wisdom.

TIPS FOR TRAVEL PREPARATION

- Don't publicize your travel plans. Limit that knowledge to those who need to know. Leave a complete itinerary (including contact numbers, if known) with your office and with family or a friend.

- Check the expiration date of your passport. Make three copies of the page containing your photograph. Keep one in your carry-on luggage; one in your main luggage; and one with a family member.

- Check your visas (tourist/business) to make sure the information is accurate and current.

- Take the fewest **credit cards you need** for the trip.

- Carry only the documents you will need in a wallet or purse.

- Realize all business documents might be subject to search, seizure or copying.

- Carry a U.S. driver's license with your photo on it.

Make two copies of the numbers of credit cards and traveler's checks, and telephone numbers to report loss, and air ticket numbers and keep a copy in your wallet and another in your briefcase or suitcase. (These items should be stored in separate locations to avoid losing everything at once.)

- Carry copies of prescriptions and an ample supply of any prescription medications, in original containers if possible.

- Bring an extra set of eyeglasses or contact lenses.

Carry an international shot record that certifies appropriate inoculations. List your **blood type, allergies, medical conditions and special requirements.** (Medical alert bracelets are a good idea if you suffer from certain ailments like diabetes, severe allergies, etc. Consult your doctor for more about these.)

If you don't have comprehensive medical coverage, consider enrolling in an international health program. (Hospitals in foreign countries usually don't take credit cards and most will not honor U.S.-based medical insurance plans.)

- Keep your personal affairs up-to-date. Have an up-to-date will and insurance policy. Leave a power of attorney with a family member or friend should anything happen to you.

- Adjust your sleep patterns before you leave, especially if you're traveling to different time zones. Sleep as much as you can during the flight.

- Carry airsickness medication with you.

- Avoid a demanding schedule upon arrival. Give yourself a chance to adjust to your surroundings.

- Talk with people who have visited your country destination recently.

> If you don't know anyone personally, search on-line for a chat room or user group dedicated to the country or region you're visiting. These are useful for informal "intelligence" that you won't get from tourist bureaus or government agencies.

- Check with the U.S. State Department, Bureau of Consular Affairs for traveling conditions and warnings. You can go to their Web site at *www.state.gov* to access an enormous array of information—including the travel alerts and places to avoid. Or call (202) 647-5225.

- Always reconfirm onward flights at least 72 hours in advance.

> Travel advice, including warnings about certain countries and regions, is issued regularly by the State Department and is frequently updated. Read it before you depart. Read it before you book flights. In addition to the governmental information sources, you can further your research by accessing travel and educational Web sites like Lonely Planet and Infoplease, and other general media outlets. These can lead you to other expert resources to deepen your knowledge about the countries' cultures.

Another useful site is the new **Department of Homeland Security**'s Web site at *www.dhs.gov*. This site allows you to access information about travel alerts, illnesses and diseases in other countries, border wait

times, passport services, goods you can and cannot import/export, customs and inspections, and your requirements for leaving and returning to the U.S.

- Use airlines, hotels and car companies that are recommended by your travel agent.

- Ask your travel agent about the need for an international driver's permit.

- Items of value, such as cameras and laptop computers, can be registered with Customs before departing the United States. The embassy of the country you plan to visit can provide a list of Customs restrictions or banned materials. (Minimize the possibility of an encounter with the local authorities.)

Luggage Tips for Traveling Abroad

☐ If at all possible, carry on your luggage.

☐ Carry sensitive information in your hands (carry-on bags or on your person).

☐ Consider buying a special carrying "wallet" for your passport, credit cards and cash. These wallets are designed to hang around your neck or strap around your waist for safekeeping.

☐ Tag your luggage with covered tags.

☐ Put your name and work address inside each piece of luggage and be sure it is secured. Use your work address and telephone number.

☐ If the locks on your luggage are not secure, for added security, run a strip of nylon tape around the suitcase.

☐ Consider insurance coverage for lost luggage; ask your airline or insurance carrier.

☐ Do not over pack bags.

☐ Do not transport items for other people. Any gifts received from a foreign business contact should be thoroughly inspected before being placed in your luggage.

☐ Leave all expensive and heirloom jewelry at home.

☐ Never place your valuables (money or traveler's checks) in checked luggage.

☐ Never leave your bags unattended.

☐ If available, obtain a modest amount of foreign currency before you leave your home country. (Criminals abroad often target foreigners purchasing local currency at airport banks and currency exchange windows.)

CHECK-IN SECURITY

It's important when you're traveling—and, really, whenever you're in a public place—to keep alert to yourself in relation to your surroundings. Specifically, this means:

- Scan the room for exits—standard and emergency. If trouble comes, you need to know how to avoid it and get out of the area.

- Locate all uniformed security personnel. Be aware of which are examining travelers.

- Scan the other travelers. Stay away from people who look like they might cause problems—or delays—with security personnel.

- Check in early; avoid last minute dashes to the airport. Rushing creates confusion.

- Go directly to the gate or secure area after checking your luggage.

- Avoid waiting rooms and shopping areas outside the secure areas. Don't linger around transit centers.

- At many airports, security personnel will ask you questions about your luggage. Know what items you are carrying and be able to describe all electrical items.

- Do not exchange items between bags while waiting for security screening or immigration or customs processing.

- Cooperate if a conflict should arise while undergoing the screening process.

- At most airports, X-ray machines will not damage film, video tapes or computer equipment. Therefore, such items

can be cleared in this way without being handled by a screener.

- Dress casually, to avoid attention. Wear shoes that come off easily for security checks.

- Do not accept or deliver letters, packages or anything else from anyone unknown to you.

- Go in the opposite direction of any obvious disturbance. Don't get involved.

Once you reach your destination, try to arrange a pickup at the airport from someone you know or from the hotel where you'll be staying. Foreign visitors arriving in the U.S. on a visa may have to have their fingerprints and photographs taken. Customs officials can instantly check an immigrant or visitor's criminal background.

HOTEL SECURITY

There's a lot to protect when you're away from home and staying in a hotel—whether it's a five-star hotel or budget inn. Some tips:

- Avoid random, unknown hotels. Use hotels recommended by friends, business associates (i.e., the corporate travel agency) or your travel agent.

- If you can, make your own reservations; the fewer people who become involved in your travel and lodging arrangements, the better.

> If traveling abroad, especially in high threat areas, consider making reservations using your employer's street address, without identifying the company, and using your personal credit card. Again, the less known about your travel itinerary, and who you represent, the better.

- If arriving in mid-afternoon, ensure that reservations are guaranteed.

- Ask about hotel parking before renting an automobile.

- Be aware that credit card information may be compromised by hotels, rental car companies and restaurants. Use as few cards as possible. Always audit monthly credit card statements to ensure that unauthorized use has not been made.

The most vulnerable part of your journey is **traveling between the point of debarkation** (getting off a plane or ship) **or embarkation** (getting on a plane or ship) **and the hotel.** So:

- Disembark as close to a hotel entrance as possible and in a lighted area. Before exiting the vehicle, ensure there are no suspicious persons or activities.

- Do not linger or wander unnecessarily in the parking lot, indoor garage or public space around the hotel.

- Avoid dimly lit garages that are not patrolled and do not have security telephones or intercoms.

- Watch for **distractions that may be staged** to set up a pickpocket, luggage theft or purse snatch.

- **Stay with your luggage** until it's in the lobby or placed in your taxi.

- Use the bellman. Luggage in their care makes them liable for your property. Keep claim checks.

- **Personal travel documents,** laptop computers, valuables and sensitive documents should be hand carried and personally protected.

- Valets should receive only the ignition key.

In some countries, your passport may be held by the hotel for review by the police or other authorities. If so, retrieve it at the earliest possible time.

Other Hotel Tips

☐ Position luggage against your leg during registration, but place a briefcase or a purse on the desk or counter in front of you.

☐ Request a room **between the second and seventh floor.** Most fire departments do not have the capability to rescue people above the seventh floor level with external rescue equipment (i.e., ladders). Look for fire escapes.

- ☐ Avoid low-level rooms with sliding glass doors or easy window access. Request rooms that are away from the elevator landing and stairwells.

- ☐ Accept the bellman's assistance upon check-in. Allow the bellman to open the room's door, turn the lights on, and check the room to ensure that it is vacant and ready for your stay.

- ☐ Inquire how guests are notified if there is an emergency.

- ☐ Find the nearest fire stairwell.

- ☐ Note the location of fire alarms, extinguishers and hoses, and read any fire safety information available in your room.

- ☐ Stay only at hotels that have smoke detectors and/or sprinklers installed in all rooms and provide information about fire and safety procedures.

- ☐ Find the nearest house telephone in case of an emergency.

- ☐ Note how hotel staff are uniformed and identified. Verify hotel employees with the front desk before permitting entry to your room.

While in the room, keep the door closed and **engage the dead bolt and privacy latch** or chain. A limited number of hotel keys can override the dead bolt locks. If you're concerned about money or valuables, have them placed in the safe deposit box at the front desk of the hotel. **Guest room safes are not secure.**

Keeping Things Private

- Hotel rooms and telephones are not *usually* bugged—even in foreign countries. But, the more you keep your business private, the better.

- Keep your hotel room key with you at all times, if possible.

- At night, **secure your passport and other valuables**. (Remember: avoid room safes and check all valuable items at the front desk.)

- Do not divulge the name of your hotel or room number to strangers.

- Be cautious about people you meet in bars, restaurants or tourist sites—especially if they are enthusiastic about speaking your language.

STREET SMARTS

When you're in a foreign place, the first thing you should do is obtain **a good map** of the city.

Note significant points on the map such as your hotel, embassies and police stations. Make a mental note of alternative routes to your hotel or local office.

Some cities aren't set up on grids so you may want to have **a compass** on hand to ensure you're headed in the right direction.

Tips for Street Safety

☐ Be aware of your surroundings. **Look up and down the street** before exiting a building.

☐ Learn how to place a local telephone call and how to use public telephones. Make sure you always have coins or a **prepaid card** for telephone use.

☐ That said, be careful of public telephones. Areas around phones are often used by criminals to stage **pickpocket activity or theft**. Keep briefcases and purses in view or "in touch" while using phones.

☐ Be careful with **telephone credit card numbers**. Criminals listen for callers to announce credit card numbers on public phones and then sell those numbers.

☐ Before walking around, educate yourself about the traffic patterns and local traffic conditions. Speak with the bellman, concierge and front desk regarding safe areas around the city to jog, dine or sight see. Ask about local customs and which taxi companies to use or avoid.

☐ Keep your passport with you at all times. Only relinquish it to the hotel if required by law when registering, or if you are required to identify yourself to local authorities for any reason.

☐ Vary the time and route by which you leave and return to the hotel. **Never**

maintain a pattern. Be alert for persons watching your movements.

☐ Use caution when entering public restrooms.

☐ Purse snatchers and briefcase thieves are known to work hotel bars and restaurants. Keep your possessions in view or "in touch."

☐ Be alert to scams involving an unknown person spilling a drink or food on your clothing. An accomplice may be preparing to steal your wallet, purse or briefcase if it is within their reach.

☐ **Pools or beaches** are attractive areas for thieves. Leave valuables in the hotel, but carry a token sum to placate violent thieves. Sign for food and beverages on your room bill rather than carry cash.

☐ Avoid people you do not know.

GUARD YOUR INFORMATION

If you're working abroad—or just another state—there are other safety precautions you should take, including the following:

• Safeguard all **sensitive papers and documents**; do not leave them lying on top of a desk or visible in your room.

• Guard your conversations so that unauthorized personnel are not able to eaves-

drop on discussions pertaining to proprietary information, personnel issues or management planning or problems.

- **Be careful of all communications**. Be aware that the monitoring of telephone, telegraph and international mail is common in some countries.

Hostile—and even friendly—intelligence organizations are often on the lookout for sources who are **vulnerable to coercion**, addictions or emotional manipulation. To reduce your chances of inadvertently doing something that would attract the special attention of one of these agencies:

- Don't do anything that might be misconstrued, reflect poorly on your personal judgment or be embarrassing to you or anyone traveling with you.

- Don't gossip about character flaws, financial problems, emotional relationships or the marital difficulties of anyone traveling with you.

- Even if you're in Amsterdam, don't carry, use or purchase any narcotics, marijuana or other recreational drugs.

If you are using a prescribed medication that contains any narcotic substance or other medication subject to abuse, such as amphetamines or tranquilizers, carry a copy of your doctor's prescription and check local restrictions and requirements prior to departure. (Some countries may require additional documentation or certification.)

- Don't let a friendly ambiance and alcohol override your good sense and capacity when it comes to socializing or fraternizing. Remember that thieves often frequent bars and restaurants popular with travelers.

- Don't engage in **black-market activities** such as the illegal exchange of currency or the purchase of religious icons or other local antiquities. Do not carry any political or religious tracts or brochures or publications likely to be offensive in the host country, such as pornography or radical magazines.

- Do not photograph anything that appears to be associated with the military or internal security of the country, including airports, ports or restricted areas such as military installations, antennae or government buildings.

- Do not purchase items that are illegal to import into the United States or other countries such as endangered species or agricultural products.

IF YOU'RE DETAINED

Most travelers' worst fear: Getting arrested in a foreign country for doing something you didn't realize was wrong—or that you just didn't do. Foreign police and intelligence agencies detain people for many reasons....or for no other reason than they're behaving suspiciously.

Always remember that you are a visitor. Be aware of the laws that govern other countries because they apply to you, too. (If caning is the punishment for spray-painting public buildings or cars, don't do it or you'll find yourself in a lot of pain.) Prior to your trip, obtain the address and location of the nearest U.S. Embassy in the host country. In the event of an emergency, you can find safe haven within them.

In all, **exercise good judgment**, be professional in your demeanor, and remember these suggestions:

- Ask to contact the nearest embassy or consulate representing your country. As a citizen of another country you have this right, but that does not mean that your hosts will allow you to do so right away. Continue to make the request periodically until they accede and let you contact your embassy or consulate.

- Stay calm, maintain your dignity and do not provoke the arresting officer(s).

- Admit nothing; **volunteer nothing** and sign nothing. Often, part of the detention procedure is to ask or tell the detained to sign a written report. Decline politely until you can get that document examined by an attorney or an embassy or consulate representative.

- Accept no one at face value. When the representative from the embassy or consulate arrives, request some identification before discussing your situation.

- Do not be tricked into helping those detaining you; it won't necessarily get you released quicker. They can be very imaginative in their requests for your assistance. Do not sell yourself out or agree to do anything. If there appears to be no other way out, tell them that you will think it over and let them know. Once out of their hands, **contact your embassy** for assistance in getting out of the country.

In many of the world's leading danger zones—Mexico, Columbia, Venezuela, Brazil, Nigeria and the Philippines—the kidnapping of North American executives is a growth industry. Kidnapping foreigners, along with well-to-do locals, has become a way of life for rebel armies and gangs of criminals.

If you and your family are venturing to a foreign country for an extended period of time, you might want to consider **kidnap and ransom (K&R) insurance**. Ask your employer or personal insurance carrier for this kind of coverage.

> **About two-thirds of kidnapping cases, ransom is paid, and the average payment is about $2 million. K&R insurance typically covers: ransom and extortion payments; hiring professional security consultants and negotiators; theft of ransom money; death of victims during rescue; transportation costs; and payments to informants.**

Remember: Don't assume that you're immune because you're not rich. The most frequent kidnapping

targets are **middle-class executives and their families**. Wealth is relative. A middle-class income in the U.S. may well place you on the top end of the scale in some of the world's most dangerous nations.

When traveling abroad, maintain a low profile and don't advertise your wealth. Leave your flashy clothes, glittery jewels and luxury car at home. Other tips:

- Vary your routine. Don't travel the same road, jog the same path or eat at the same restaurant every day.

- Only use official taxi stands. Again, ask your hotel which companies to use.

- Steer clear of isolated or rural areas.

BUSINESS ABROAD

When doing business abroad, watch out for potential hazards and unwarranted interest in your activities.

> **The four types of threat to businesses abroad: competitors, criminals, terrorists and governments. You could be targeted by any one of these entities.**

In troubled spots, it may be wise to stay in a "foreign national enclave" with your countrymen and rely upon one another for assistance.

Offices, desks and files should be locked during non-working hours. Unannounced security sweeps should

be made periodically, with lapses reported and corrective action taken.

Personnel files should be guarded carefully. Deny access to everyone except people who have been approved by your home office.

THINGS TO WATCH

- Repeated contacts with a local or third-country national who is not involved in your business interests or the purpose of your visit, but, as a result of invitations to social or business functions, appears at each function.

- Representatives of the host government. Be cautious and don't allow the relationship to develop any further than the business level.

- Accidental encounters with an unknown local national who strikes up a conversation and wants to: practice English or another language; talk about your country of origin or your employment; buy you a drink because he or she has taken a liking to you; talk to you about politics.

- Be observant and **pay attention to your instincts**. If you get the funny feeling that something is not right or that you are being watched, report your suspicions or any information to the general manager of the local affiliate or your embassy or consulate just in case something does occur.

- If you have reason to believe that you are under surveillance, continue to act naturally. Do not try to slip away, lose or embarrass the surveillance as this may anger and alert them. It also may cause them to question whether you are, in fact, a tourist or business person.

- In your hotel room, don't play investigator and start looking for electronic listening devices. Don't say or do anything in your hotel room that you would not want to see printed in the local paper.

More Streetwise Tips

☐ Try to stand or sit where you can see all—or several—exits.

☐ Always take note of emergency exits.

☐ Try to walk on well-lit, heavily-traveled streets. Avoid short cuts and stay in the middle of the pavement.

☐ When walking, walk facing the traffic.

☐ When using elevators, stand near the control panel.

☐ Before leaving an elevator, check the hallway.

☐ Assume all radio and telephone calls are being intercepted.

☐ Keep as mentally and physically fit as you can. You will deal better with a crisis and have faster reactions.

- ☐ Pay attention to how you dress. Don't stand out.

- ☐ Guard your home address and telephone number. Do not display them on your luggage. Use your business address, instead.

- ☐ Beware of scams designed to separate you from your luggage.

- ☐ Carry a dummy wallet containing low denomination notes and credit card look-alikes that you can surrender in an incident like a street robbery.

- ☐ Consider parting with small "gifts" for key personnel. If the hotel staff treated you kindly, met your personal—and security—needs, reward them and consider returning to the same hotel in the future.

- ☐ Do not give away sensitive information in discarded rubbish and waste paper.

TIPS, FEES...AND BRIBES

Most travelers incarcerated are involved in **traffic- or drug-related offenses**. Many countries—especially undeveloped ones—have an unofficial method of dealing with less serious problems.

If a local law officer offers to resolve or "fix" a problem rather than write you up or arrest you, he or she may expect you to begin negotiating a "special fee." At home, you'd probably call this a bribe..

Bribes are a cash-only business. The amount you pay will usually be limited to the amount of cash you have on you at that moment.

> Never initiate any conversation of "fixing" a legal problem with a "fee." But be aware that a law enforcement officer—especially a local one—may hint that a fee will help resolve a problem quickly.

Never offer money or suggest an amount or the reason for the payment. Typically, an officer will present you with a "problem" that can be solved but will take time, money or approval by a higher authority. Express your desire to **resolve the problem** in the fastest and most efficient way.

> Keep in mind that offering cash to an officer—however innocently—is usually illegal and can land you in jail. But unofficial payments are a fact of life in some places. Africa is the worst place for bribery, followed by South America and Central America. North America and Europe don't tolerate bribes. Even small ones.

A special fee probably *won't* work if you are arrested by the military, make the local papers or do something the government is trying to eradicate—usually with U.S. funds—like the smuggling of drugs, weapons or people. If you're caught smuggling those things, you may be in more trouble than a "fee" can fix.

> **Small bribes are used to facilitate services that can be withheld or denied. Some countries look on these payments as a kind of tipping. When a country lowers it wages to its police and officials below the poverty line, they look to you to make ends meet.**

A carton of cigarettes might get you quickly processed in most African countries; a bottle of Johnny Walker will slow you down in a Muslim country but expedite your exit visa in South America. With these kinds of gifts, you may not need a visa to enter or leave a country; and the customs officials may forgo an inspection of you and your belongings/vehicle.

Final note: Most of us don't have to bribe our way across borders and through shady propositions. But if you're traveling in a foreign country, you can't predict what you'll come up against.

> **Don't assume that "being American" with a U.S. passport will protect you in any way. Even if you manage to contact the American Embassy in the country where you're in trouble, it won't be able to get you out of jail easily or quickly. No one can save you but yourself when you're in a foreign land.**

IF YOU'RE BEING FOLLOWED

Next to being detained, most foreign travelers' biggest fear is being followed. Here are some tips to remember if you think you're "being tailed":

- [] Use a cellular phone to request police assistance. Give your present location, the direction you are traveling, and the license number of the following vehicle.

- [] Don't stop or force a confrontation. Drive to a local police station.

- [] As an alternative, drive to a shopping center, theater or other busy area.

- [] If you cannot locate a suitable and safe stopping point, **lean on the horn** and keep it blowing to attract attention and deter your attackers.

- [] Maintain a safe distance from all cars ahead of you.

- [] Be alert to motorcycles following you or leading you closely.

- [] Stay alert to any bicycle using the road in front of you. It could be an attempt to slow your car.

- [] Maintain **special vigilance** at traffic and stop signs any time you stop or slow.

- [] Beware of disabled vehicles or vehicles at intersections, especially if there are groups of people nearby. Any car following you can box you in.

CONCLUSION

Traveling in a post-9/11 world requires new security measures and personal precautions. This chapter gave

you a few tools to use when you go away from home…as well as a few things to think about.

Confer with your government's foreign office before departure and check in with their representative on arrival. Where possible, give your embassy or consulate a **copy of your itinerary**, at least on a per-city basis. Take their advice on special precautions.

For each country on your itinerary all members of your party should **learn native phrases** such as, "I need the police" (or doctor, telephone hospital, your country's embassy). Learn the numbers in that language.

9

TERRORISTS &
SWINDLERS

When the commercial airliners hijacked by members of the al Qaida terrorist organization attacked the World Trade Center in New York and the Pentagon near Washington, D.C., approximately 3,017 people were killed or declared missing—including 147 on the two hijacked planes and another 224 in the attack on the Pentagon and in the hijacked plane that crashed in Pennsylvania.

The financial impact of the attacks was large and hard to quantify. Even if you leave aside the impact the attacks had on the financial markets—and focus only on direct costs—the losses were in the tens of billions.

Insurance paid for a lot of the financial loss (and the effect that these payments have had on the insurance and financial services industries has caused a second-hand ripple in the broader economy).

But the effects of 9/11 go beyond the dollars.

Terrorism counts on **misdirected fears and exaggerated response**. In the days after the bombing of

the Alfred J. Murrah Building in Oklahoma City on April 19th, 1995, telephone bomb threats led authorities to evacuate government buildings in New York, Detroit, Dallas, Cincinnati and various cities in California.

Some people expected the perpetrators of the Oklahoma City bombing to be agents of some foreign political group. However, the people responsible turned out to be native sons. Timothy McVeigh, a former soldier with right-wing leanings, and a handful of accomplices planned and executed the crime.

> Just as the initial ideas about who committed the crime were wrong, the ideas about terrorist attacks impacting most Americans were wrong. America is a big place with a lot of people living in it—the overwhelming majority of whom will not be affected directly by terrorism in their lifetimes.

Despite the fears caused by the Oklahoma City and World Trade Center bombings, the greatest risk of terrorism loss occurs for most Americans when they travel abroad.

Everyone fears the most rare and tragic of circumstances when they travel abroad: the fatal terrorist attack. Political risk experts acknowledge that the lines between political terrorism, organized crime and drug and arms dealers are becoming increasingly blurred and hard to discern. As a result, **identifying the source of threats** to international companies and their employees is becoming more complicated.

Security experts say it's difficult to tell what kind of group is threatening who and why. Since the end of the Cold War, the ideological basis and state backing (for terrorism) have gone. Many groups are involved with drugs or weapons dealing.

What steps can you take to protect yourself from terrorists? This question is more difficult to answer, because the best precautions are things that require **government-level regulation of public spaces**. So, you can press your local government to take effective measures and hope that authorities make effective changes.

In April 2002, New York Governor George Pataki proposed a plan to sharpen security at New York City's area airports. This plan went beyond federal requirements—and it serves as a good example of a thorough response. The plan included:

- installing fingerprint scanners quickly to control access for all airport employees and do away with simple plastic passes;

- installing more sophisticated cameras, motion detectors and other devices around the perimeters of the facilities, including ground-based radar and a new array of low-light and infrared closed-circuit cameras;

- requiring detailed background checks for security guards and people working on the aircraft or handling baggage;

- requiring the same checks—including criminal reports—for vendors, food service workers and other employees of companies doing business within the facilities; and

- providing counterterrorism training for the state and local police.

> The most important piece of the plan—in the eyes of security officials—was the investigation of the people working in shops and restaurants. A terrorist might not be able to smuggle explosives through a checkpoint; but a confederate at one of the shops could do so. Even a knife used to cut meat at a restaurant might be passed on to a potential hijacker.

A host of new airport screening methods went into action at the start of 2004. All 115 U.S. airports, for example, that handle international flights and 14 major seaports are required to fingerprint foreign visitors that enter the country with a tourist, business or student visa. Their photographs are also taken; this information can be used to perform criminal background checks. This program is called US-Visit, or US Visitor and Immigrant Status Indicator Technology. It will check an estimated 24 million foreign visitors annually. Some exceptions are allowed in the waiver program, which permits citizens mainly from European nations (and Japan and Australia) to visit for up to 90 days without visas.

Finally, though, the important thing to remember about protecting yourself from terrorists: If you become

the victim of a crime, the crime is much more likely to be a theft or burglary...a **crime against your property**. You can protect yourself most effectively by taking actions to prevent *that* kind of crime.

Because terrorism is a public crime, it requires public (usually governmental) prevention.

If you don't travel that much, you may worry more about biological or chemical attacks in your hometown or being in the wrong place at the wrong time when a dirty bomb hits. The media has made everyone concerned about the possibility of an attack of some kind—it's no longer a problem in far-off lands.

BIOLOGICAL ATTACK

A biological attack is the deliberate release of germs or other biological substances that can make you sick. Many agents must be inhaled, enter through a cut in the skin or be eaten to make you sick. Some biological agents, such as anthrax, do not cause contagious diseases. Others, like the smallpox virus, can result in diseases you can catch from other people.

Before the fall of 2001, inhalation anthrax—regarded as the most serious form of the bacterial infection—was considered fatal about 80 percent of the time. The cases that emerged after 9/11, however, proved that exposure to inhalation anthrax can be treated successfully with early detection and an aggressive antibiotic regimen.

DURING A BIOLOGICAL ATTACK

You might now know that you're under a biological attack when it starts. Although you might see signs of an attack like those seen during the anthrax mailings, most likely the local health care workers will report a **pattern of unusual illness** or there will be a wave of sick people seeking emergency medical attention. That's what governments are trained to look for.

You will probably learn of the danger through an emergency radio or TV broadcast, or some other signal used in your community. You might get a telephone call or emergency response workers may come to your door.

During a biological attack, public health officials may not immediately be able to provide information on what you should do. It will take time to determine exactly what the illness is, how it should be treated and who is in danger. Watch TV, listen to the radio and check the Internet for official news. Obtain as much information as you can on all of the following:

- The group or area authorities consider in danger;

- The signs and symptoms of the disease;

- The medications or vaccines being distributed for the threat;

- Where the medications and/or vaccines are being distributed; and

- Where to seek emergency medical care if you or any family, friends or co-workers become sick.

When a biological emergency is declared, it's easy to see every symptom as a sign of illness. While you need to be suspicious of any sick person you come into contact with, be smart about responding. Do not automatically assume that you should go to a hospital emergency room or that any illness is the result of the biological attack. Symptoms of many common illnesses may overlap. The best responses are common-sense matters:

- Use common sense;

- Practice good hygiene;

- Avoid spreading germs; and

- Seek medical advice when appropriate.

If an unusual and suspicious substance has been released nearby:

- Get away quickly.

- Cover your mouth and nose with layers of fabric that can filter the air but still allow breathing (e.g., layers of cotton such as a t-shirt, handkerchief or towel).

- Wash with soap and water and contact authorities.

CHEMICAL ATTACK

A chemical attack is the deliberate release of a toxic gas, liquid or solid that can poison people and the environment. Examples include sarin (a colorless vapor that smells like Juicy Fruit gum) and cyanide (smells like burnt almonds).

Signs of a chemical attack include:

- You have watery eyes, are twitching, choking, having trouble breathing or are losing coordination.

- There are sick or dead birds, fish or small animals around you.

If you can determine what area is affected and where the chemical is coming from, take immediate action to get away and take the following precautions:

- If the chemical is inside a building where you are, get out of the building without passing through the contaminated area, if possible. Move as far away from where you suspect the chemical release is and shelter-in-place.

- If you are outside, quickly decide what is the fastest escape from the chemical threat. Consider if you can get out of the area, or if you should follow plans to shelter-in-place.

If your eyes are watering, your skin is stinging and you are having trouble breathing, you may have been exposed to a chemical. If you have been exposed:

- Strip immediately and wash.

- Look for a hose, fountain or any source of water, and wash with soap, if possible. Be careful not to scrub the chemical into your skin.

- Seek emergency medical attention.

> If there has been an actual or suspected exposure to a chemical or radiological agent, local government officials will set up screening and decontamination locations. This is a place where you will be screened for any agent you may have been exposed to.

NUCLEAR BLAST

A nuclear blast is an explosion with intense light and heat, a damaging pressure wave and widespread radioactive material that can contaminate the air, water and ground surfaces for miles around. You've probably seen nuclear tests shown on television or in the movies (the big mushroom cloud).

While experts suggest that a nuclear attack is less likely to occur today than other types of attacks (because global nuclear war would be suicidal to the entire planet), **terrorism by its nature is unpredictable**. You don't know who might decide to use nuclear power.

Hopefully, you'll receive warning about a possible nuclear blast before it occurs. Due to the destructive—and definitive—nature of nuclear warfare ("You hit me with a nuclear bomb, I hit you...and we destroy each other"), the threat of global nuclear war is arguably less than the threat of smaller, more localized and subtle attacks.

While the Cold War is over, the War on Terror has renewed people's fears of a nuclear explosion. A day may come when you need to survive such a brutality

and seek the nearest fallout shelter (assuming you haven't built one yourself on your property).

To increase the chances of surviving a nuclear blast:

- **Take cover immediately**, below ground if possible, though any shield or shelter will help protect you from the immediate effects of the blast and the pressure wave.

- Assess the situation.

- See if you can get out of the area or if it would be better to go inside a building and follow your plan to shelter-in-place.

- Limit the amount of radiation you are exposed to (think about shielding, distance and time).

- Use available information to assess the situation.

Key Concepts

- **Shielding**: If you have a wall between yourself and the radioactive materials, more of the radiation will be absorbed and you will be exposed to less.

- **Distance**: The farther away you are from the blast and the fallout the lower your exposure.

- **Time**: Minimizing time spent exposed will also reduce your risk.

- Consider keeping potassium iodide in your emergency kit.

- Learn what the appropriate doses are for each of your family members.

- Plan to speak with your health care provider in advance about what makes sense for your family.

A MORE LIKELY THREAT

A radiation threat or "**dirty bomb**" is the use of common explosives to spread radioactive materials over a targeted area. It is not a nuclear blast. The radioactive contamination is more localized.

> **While such a blast will be immediately obvious, the presence of radiation will not be clearly defined until trained personnel with specialized equipment are on the scene.**

As with any radiation, you want to try to limit exposure. Follow the same guidelines as you would for other blasts: think about **shielding, distance and time**. Talk to your local health or public safety officials if you're concerned about this kind of threat.

The risk is not large enough to make anyone spring for fancy equipment (like a Geiger counter) to have at home that can detect radiation. You'll rely on your news and local officials to keep you informed...as soon as they've gathered the information.

> The cancellations of flights over the holiday season in late 2003, early 2004 (e.g., Air France and British Airways' flights to the U.S.) were caused by worries over a dirty bomb aboard, among other concerns.

As with any emergency, local authorities may not be able to immediately provide information on what is happening and what you should do. However, you should watch TV, listen to the radio or check the Internet often for official news and information as it becomes available.

> It's vital to have your disaster supplies kit fully stocked, including at least three gallons of water per person in your household for drinking purposes. If you choose to shelter-in-place in the bathroom, you can fill the tub with water and use for bathing (not for drinking).

EMERGENCY WATER SHORTAGE

An emergency water shortage can be caused by prolonged drought, poor water supply management or contamination of a surface water supply source or aquifer. Concerns that terrorists may distribute a poisonous agent via the water supply has alerted officials to find new ways of protecting the water supply to assure people that the water is safe.

Water is something we all need every day for survival.

When there's an emergency, people flock to their local supermarket for water first, then food. As we've mentioned throughout this book, stock up on emergency water supplies *before* the rush. In between the shortages, continue to use water wisely.

Notes on Terrorism

- Every community cannot be equally vulnerable at the same time to terrorism.

- You can only do so much to prevent terrorism from occurring.

- Staying calm and organized during an attack is going to benefit you and your family more than becoming hysterical.

- Always remember to keep children in mind; tell them what is happening and keep them informed.

- Take inventory of your supplies, making sure you have enough food and water for your family in the event you cannot go to the supermarket for several days. During those days when you're safest in your home, be careful how you consume your supplies, particularly your water. Stock up on things you use frequently.

SWINDLERS

We started this chapter by talking about terrorism and how to prevent or deal with a terrorist attack. We also said in the first page of this chapter that the events

of 9/11 **distorted people's notion of risk**. It misdirected people's fears and gave the media a free pass to exploit the worst-case scenario *what-if*s.

If you're more worried about boarding a plane or attending the Super Bowl than giving a telemarketer your Social Security number or ordering a no-hassle, no obligation weight-loss kit from a TV commercial, your sense of personal security is warped.

Chances are, you're not going to be a victim of a horrific crime or a terrorist attack. Instead, you'll be duped by the scammers and swindlers that live next door and act like Mr. and Mrs. Niceguy. When you think about it, terrorism is largely out of your control. You're not in charge of screening people, handing out visas or conducting background checks on suspicious people.

A lot of terrorism prevention is up to the federal and state governments—particularly the Department of Homeland Security and the agencies with which it corresponds. At the lower level, you have to rely on your police departments, port authorities, etc., to prevent such attacks and deal with them when they occur. So, **terrorists should not be the people on your daily alert list**. Rather, the scammers and swindlers should be. You have much greater control over whether you get victimized by a swindler or scammer than you do getting victimized by a terrorist.

Just about everyone has something to sell. Whether on the Internet, through the mail, over the

telephone…or even at your church…you're likely to hear pitches about **cheap credit, easy weight loss** or **can't-miss investments**.

Many of these excited proposals are scams—financial swindles designed to **take your money**. Keep in mind:

- The Internet has increased the efficiency with which scams can be promoted. In some cases, the scams are on-line variations of old-fashioned swindles ("old wine in new casks," as one law enforcement official said). In other cases, the scams are designed particularly for the on-line environment;

- There's **no such thing as insurance against getting scammed**. Your credit card company may offer you some recourse against a bogus charge; some Internet commercial sites may offer precautions; and

- Only you can protect yourself against being ripped off.

INTERNET AUCTION FRAUDS

Buying things—from obscure collectibles to concert tickets—through auctions on the Internet has been one of the biggest successes in e-commerce. But the most common form of Internet scam is the **on-line auction fraud**. (We talked a little about this in Chapter 4.)

Most auction frauds are simple variations on the classic "bust out" scheme. In these schemes, a crook opens a business or offers goods for sale on-line. He then accepts payments for the goods (and, sometimes, credit for supplies) but never makes any products or pays any bills. He stays in contact with customers and creditors as long as possible—without honoring any commitments. Finally, he disappears, leaving customers and creditors empty-handed.

> Internet auctions are a good environment for crooks because they are administered—but not really controlled—by well-known large companies. Crooks are often drawn to circumstances that allow people to be confused about identity.

The auction services don't make any promises about the people selling things on their sites. If you're planning to buy something on-line, the auction company will make the bidding easy and relatively fair. It will offer some payment options, once the deal is done. And it may take a small fee for these services. But it's only a middleman—you're doing business with someone you've never met...and probably never will. That's inherently risky.

> Most auction sites offer some form of seller ratings. These are programs that invite buyers to rate the seller and the deal on various scales, all designed to give other buyers some idea of what they can expect from the individual sellers.

However, to protect yourself from getting scammed, you need to take a few extra steps:

- **Look beyond rating scores**. Read through the detailed comments that back up ratings—look for clues in even mild complaints. Comments like "frustration" and "delay" even in positive feedback can be signs for problems.

- **Look at the seller's history**. Again, this means more than just ratings. Has the seller ever sold the kind of product you're buying? Ideally, he or she has sold at least a few products like the one you're buying. The more expensive the product, the more important this becomes.

- **Know how you got to a site**. One of the trickiest aspects of the Internet is the cloudy connection that exists among many Web sites. Many times, you may not even be aware which site you're on when you see something you want to buy. And many sites like it that way.

- **Avoid off-site auctions**. Some crooked outfits will pressure you to move off of a recognized auction site and do business privately. This way, the seller can avoid that level of scrutiny.

- **Ask for contact information**. Even though the Internet ethic is steeped in anonymity, there are many secure ways to exchange contact information. You're in your rights to ask for names and phone numbers.

Another smart protection may seem to run against the spirit of on-line commerce: **Keep a paper trail**. More specifically:

- print a hard copy of the Web site's main page;

- print a hard copy of the product detail page;

- print hard copies of all e-mails between you and the seller;

- investigate the public information related to the registry of the Web site (*internic.net* and *networksolutions.com* are the best sites for this); and

- print hard copies of all exchanges with the Web site's Internet service provider (ISP).

Again, your biggest risk from doing business on the Internet is that you pay for something the seller never delivers. Several of the larger auction sites (including eBay.com and amazon.com) offer some kind of **protection against nondelivery** of goods sold on their sites.

In most cases, you will have to absorb a **deductible** equal to 10 percent of the purchase price of the non-delivered goods. You'll also have to fill out various forms stating that you've been scammed.

Also, if you paid by credit card, you may have some success going to your card company. Most offer some form of "customer protection"—which will usually mean **refunding part of all of the charges** on your card.

A caveat: Credit card companies may require con-siderable documentation—including various sworn statements—from you. And their response time can be quite slow. They take a long time to refund dis-puted charges as a form of protection against the chance that your complaint is bogus.

There's another payment option that can be even more secure than a credit card. A number of **escrow com-panies** have cropped up on the Internet. These com-panies hold your payment on behalf of the seller un-til you have reported that the goods are received. Once you indicate receipt, the funds are released.

On-line escrow services are particularly valuable for larger transactions. If you're planning to spend more than $500 on a purchase, an escrow service is worth whatever fee it charges.

There are other things that you can do to improve your chances of getting money back if you think you've been scammed on-line:

- Confirm that a fraud has been commit-ted. Some problems turn out to be basic disputes between buyers and sellers.

- Make sure to stay in contact with the seller. State clearly that you will make a formal complaint if you don't get satis-faction.

- Take advantage of complaint channels. Many on-line auction services invite buyer feedback; bad reports about specific sellers can pressure them to improve their behavior...or stop selling.

CHASING THE CROOKS

If you're dealing with a hardened crook, threatening formal complaint may not do much good. But it will keep the pressure on the crook to make good on some promises made.

You may not have much success suing a crook yourself. In many cases, the crook will be in another state...if not another country. Plus, smart crooks keep each individual theft to a relatively small amount—and count on human laziness to prevent discovery.

You can investigate on your own. A number of the largest Internet search engines (including Yahoo!, Google and others) include **reverse e-mail services**, which can track the origins of e-mails you receive.

But, ultimately, you'll need to count on law-enforcement agencies to take action. Although the Internet values secrecy and anonymity, law enforcement agencies usually have the authority to get **personal information** from credit card processing services, wire-transfer services and banks.

In cases where your relatively small loss is part of a larger fraud, law enforcement agencies may have a keen interest in tracking down the **identity and location** of the scammer.

DIET SCHEMES

The Internet is still relatively new. Another of the most common scams is one of the oldest—promising people weight loss without effort or self-denial. The next chapter will detail the things you need to know when it comes to your diet and health. But it's worth mentioning the scams ubiquitous today given the weight problem Americans face and people's resulting vulnerabilities.

> **More than 60 percent of American adults are overweight. A smaller, but still disturbing, number of American children are also overweight. In 2000, Americans spent more than $35 billion on diet books, supplements, exercise equipment and other weight-loss items. It's little wonder that weight loss scams remain stubbornly common.**

In 2002, the Federal Trade Commission released the results of a survey it had taken of diet ads in major media outlets around the U.S.

> ### According to the FTC Diet Scam Survey:
>
> - About 40 percent of 300 ads surveyed made at least one "blatantly false" claim.
>
> - More than half made claims that were unsubstantiated. Some ads promised

rapid weight loss without surgery, diet or exercise; others claimed that their products allow users to "eat all [they] want and still lose weight."

- The promises made in ads were **strangely specific**. Boasts included things like "lose 10 pounds in 48 hours" and "lose weight without exercise or diet." Ads are filled with lots of exclamation points!!!

- Many of the products are dietary supplements that purport to **block the body's ability to digest fat or carbohydrates**.

- The products may not been illegal. But false advertisement of the products.

The FTC is limited in what it can do. It took legal action against 81 weight-loss advertisers in 2001. This had little effect against the waves of ridiculous ads.

Most doctors paid little attention to the dietary supplement market until 1993, when a Harvard Medical School researcher reported that **34 percent of American consumers** used some form of unconventional medicine—including everything from herbal remedies to spiritual healing.

This report made **alternative medicine and diet supplements** a big deal for physicians. Celebrity doctors like Andrew Weil and Robert Atkins who advocated diet supplements hastened the trend. A number of doctors have taken to suggesting diet supplements—and selling them directly in their offices.

Some diet supplements may alter, slightly, how your body processes food. This may help you lose weight. However, generally, there are no shortcuts to permanent weight loss. If you want to lose weight, you need to commit to a regimen of a low-fat diet, limited snacking and regular exercise.

INVESTMENT SWINDLES

The dot.com bubble of the 1990s struck many people as a big, economy-wide swindle. In truth, the investment mania **gave cover to real crooks**. (Again, crooks like confusion.) There was an increase in the number of financial scams reported all around the United States—and *that* boom lasted after the dot.com bubble had burst.

The most common investment swindle of the 1990s and 2000s was the **Ponzi scheme**—another old-fashioned fraud.

A Ponzi scheme isn't complicated, mechanically. The perpetrator collects money from investors, promising huge returns in a matter of months or weeks. Then, he has to do one of two things:

1) return a portion of the money as profit while convincing investors to keep their principle (which is dwindling fast) invested; or

2) recruit new investors, whose money is used to produce the promised windfall to the earlier ones.

Most people refer to this kind of ploy as a pyramid scheme. Even if the crook does the first thing, he'll eventually have to do the second.

Finding the **second level of investors** is usually the hardest part of the scheme. Once they are recruited, the scheme often drives its own growth. This is why a certain level of **word-of-mouth publicity** is essential to a scheme's success. When word of early profits and ritzy investors spreads, new investors pour in, allowing the crook to pay off more people.

> **Basically, a lot of cash is moving around but none...or very little...actually goes to anything that turns a real profit. The crook can maintain the charade and skim off money for himself as long as new suckers are found. When this cash flow dwindles—even slightly—the whole scheme collapses because you need more and more people to come in as investors to pay off the few original investors at the top.**

The schemes may yield returns for those who start them or join early. As long as there are enough people to support the next level, people above are safe. In financial circles, this is known as the "**greater fool**" **theory**. As long as you find someone willing to take your place in the scheme—a greater fool—the fact that you were a fool to invest doesn't matter.

The greater fool theory applies to more than just crooked schemes. Paying $40 million for a French Impressionist painting, $500,000 for a baseball card or a year's salary for a tulip bulb might make sense if

there is someone willing to pay even more. But it's absolute folly if there's not. This **fiscal relativism** blurs many people's judgment about all investments.

NUMBERS NEVER ADD UP

Like a chain letter, investment swindles are dependent on each new level of participants securing more persons to join. The new participant makes payment to the person on top of the list or pyramid, who then is removed and replaced by those at the next level.

In a four-level scheme, for the first group of participants to be paid, 64 people need to join. After 20 levels of new participants, 8,388,608 additional investors would be needed. And there'd be a total of **16,777,200 people involved**. These numbers are a practical impossibility—and why the schemes fail.

Of the factors that allow Ponzi schemes to flourish, **misplaced trust** is most important. It's the point on which burned investors—once they learn they've lost money—most often blame themselves. Invariably, the person will offer some version of "I can't believe I trusted that crook... ."

Telephones, television, computers and the Internet have shattered the traditional sense of social proportion and created an encouraging environment for swindlers. People don't trust their neighbors but believe they have a personal relationship with Oprah Winfrey or Hillary Clinton.

Most swindlers set up **legitimate businesses to camouflage their schemes**. Then, when the schemes collapse, investigators and burned investors are left wondering why someone who could build a real business resorts to theft.

The crooks may actually put a lot of work into their schemes. They're smart and make a good impression. They know they have to build at least a pretense of trust with their investors. Most tell stories or use tricks that, in retrospect, seem plainly dubious. In these cases, the best practice for avoiding a loss is to keep your eye on the traditional signs of a Ponzi scheme—exceptionally high returns combined with anything resembling a **guarantee** or **no risk offer**.

> **No legitimate investment generates guaranteed returns. And no real business opportunity is risk-free. When you invest money, there's always risk...which is why there's sometimes return.**

Many smart investment swindlers have the same characteristics and tricks of the basic telephone scammer, including the following:

- they're courteous;
- they sound concerned about you;
- they listen to your complaints;
- they flatter you;
- they try to be the surrogate son or friend you seldom see;

- they tout their financial successes;

- they offer some financial advice; and

- they tell you they can get a better return on your money.

Then they take your money.

Of course, these characteristics describe many legitimate business people, as well as crooks. The thing to watch for is the **combination of the friendly soft-sell and promises of big investment returns without much or any risk**.

PERSONAL CHARISMA

Personal charisma is one of a crook's keenest tools. Sometimes, the details of the supposed business opportunity aren't logical at all. Details may be hazy. But the size of the operation...or the posh location...or the glamorous friends and investors...make you to think that the guy must know what he's doing.

There are some recurring signs that a crook is hoping that you'll bank on his personal charisma, including:

- The crook talks about you a lot—but in general and psychological terms ("you're being decisive," "you're taking control of your life," "you're investing in yourself," etc.);

- If you ask financial questions about the investment, the crook responds in philosophical or psychological generalities;

- The crook describes himself as an "idea man" or "visionary";

- The crook talks a lot about emotional matters, such as fear, joy, happiness and love;

- The crook talks about talking, saying that he doesn't understand what you mean...or asks if you understand what he's saying; and

- The crook answers questions with questions ("What are you saying?" "How can I make you happy?" or "Are you saying you want your money back?").

Charismatic crooks will often try to turn facts on their heads. In some cases, crooks at the center of crumbling schemes—and under investigation by the SEC or the FBI—are able to convince investors that the Feds are the villains.

Crooks will often talk a lot about themselves in a **detached manner**: They embody integrity and perseverance; they are dedicated husbands, fathers or friends; they admire gurus like Tom Peters or—more literally—the Dalai Lama.

Other characteristics that crooks often volunteer about themselves include:

- They always base deals on a foundation of trust.

- They don't want money from anyone who's not comfortable about investing it—or losing it.

- They believe that financial success is secondary to personal enrichment.

- They want you to keep details of your investment private because they're not making them available to anyone else.

Indeed, some...or all...of these ideas may be valid and true. But you need to be careful about what conclusions you draw from the bunch.

Smooth crooks will sometimes offer various references with whom you can speak about investing—even before you ask. Beware of testimony from *satisfied* customers. No amount of testimony can "average out" the intent to defraud. Plus, "satisfied customers" are more than likely part of the scam to solicit new investments and reassure old investors ...while losses mount.

CONCLUSION

Swindles are an unavoidable part of a capitalistic economy (and probably every other kind of economy, too). They are also highly more likely to affect you than terrorism.

As technology advances, swindlers move into the high-tech arena. But the basic features of their schemes remain relatively simple:

- They place themselves in the context of legitimate operations—whether country club, church or auction Web site.

- They promise big, guaranteed profit with no risk.

- They talk about what you can do with all of the money you make, rather than the mechanics of their deals.

You can avoid these traps by taking **a few basic precautions**:

- Make sure you know anyone's identity before you give them money…and don't let social connections blur who's who;

- Whenever possible, transfer money through disinterested third-parties and— if possible—escrow accounts; and

- Be wary of any seller or borrower who doesn't answer your questions simply and directly.

Scams can fool even the smartest or most intuitive person. They're designed to do that. So, keep that in mind when you hear about a sweetheart deal or surefire bet. There is no reward without risk; and the higher the reward, the greater the risk.

If you're going to fret about something, focus on avoiding the next swindler more than escaping the next terrorist attack. There are far more swindlers in the world than terrorists.

CHAPTER

10

PROTECTING
YOUR HEALTH

Physical health is the ultimate security measure. In an uncertain world, there's little that anyone can control—but your body is something that you can.

Would you feel secure if you were sick, obese or unable to walk up a flight of stairs? Probably not. Would you feel secure knowing that during a disaster you'd have to rely on someone else to get you to safety? Probably not. **Being physically able is critical to your personal security.**

Health and safety go hand in hand; your security relies on both these two things. In this chapter we give you some tools for maintaining your health and enhancing your personal security.

You might not think that a book about personal security would include an entire chapter on diet and health. But **the healthier you are, the better chance you have at surviving the other risks** of life. With good health comes better ability to survive disasters, take care of and make your family safe, assist others in emergencies, work more efficiently, reduce the amount you spend on health care...and more.

DIETING

Atkins. South Beach. Perricone. Zone. Americans, like most people in the developed world, worry a lot about their diets. While **dieting to lose weight** may still be more common among middle class women than other groups, just about everyone thinks in some way about what he or she eats. The appeal of **fad diets** cuts across just about all demographic categories.

> Americans spend more than $33 billion a year on weight-loss products and services. However, the economic cost of obesity in the United States was about $117 billion in 2000.

People diet for two basic reasons: To avoid danger-ous foods and to lose weight.

> Determining what constitutes a dangerous food can be difficult. Poison can be defined as too much of anything. But how much is too much? Is there a threshold at which small amounts of foods that cause cancer or heart disease are not harmful? In most cases, no one can answer these questions with certainty.

Dietary risks, like others, are usually described in the **odds of causing a fatal illness** or in the average number of days or years by which they shorten your life. Consider these fluky factoids:

- Drinking milk every other day adds a one in 7,200 chance of getting liver cancer from a mold that produces aflatoxin—a naturally-occurring carcinogen.

- Three pats of butter on a slice of toast takes a half hour off your life.

- A steak dinner, complete with a snifter of brandy after, will cut 20 minutes off your life (this sounds like a bargain compared to the three pats of butter).

All of these statistics are of questionable value, though. They're usually based on one of two methods—both of which have flaws.

Some numbers are based on **aggressive extrapolation** from dietary impact charts, which lose their effectiveness the farther they move from real numbers. In the case of the three pats of butter, the figure is taken from an American Heart Association study on fat intake over a lifetime. To take such a small conclusion out of a lifetime measure renders it meaningless.

Furthermore, **cancer statistics** are often based on animal tests, which have an important flaw: animal experiments involve large doses. Thus, to pinpoint a risk of one in a million, you'd have to perform a million tests, involving as many as 1,000 animals each. The cost would be prohibitive.

The best scientists can do is experiment with large doses, adjust for the weight and metabolic activity of the animals compared with humans...and project the possible results of small doses on people.

A lot of guesswork is involved. Take, for example, the synthetic sweeteners Nutra-Sweet and Equal. Large doses of those cause cancer in mice—but you'd have to consume an unrealistic amount to be at the same risk as those mice. And yet, you are forewarned on the label "**May cause cancer.**"

Of course, not everyone diets to avoid cancer or strokes. Many people diet because they want to lose weight. This involves one main risk: That you'll regain whatever weight you lose.

Begin a denial-based diet and you'll probably lose weight. For how long is an entirely different question.

> Losing weight at the rate of one-and-a-half to two pounds per week produces the best long-range effects. Many experts say this means making realistic changes to your life-style in the way you eat and how much you exercise.

NUTRITION & SUPER-NUTRITION

Through the early 1990s, an intense debate took place in scientific circles over whether some nutrients, such as vitamins C and E, calcium, coenzyme Q_{10} and Zinc—taken at levels well above the federal government's recommended daily allowance (RDA)—provide benefits beyond their traditionally defined "essential functions."

The use of foods for medical purposes dates back many centuries. But advocates of super-nutrition base

their position on modern science—specifically, anecdotal evidence that certain nutrients, taken in huge doses, can reverse things like early-stage cancer tumors.

Scientists argue that cancer is not an on-off switch. It's more like **a gradual deterioration with built-in stops.** These stops are biological mechanisms: DNA repairs, cell-to-cell communications and other mechanisms in the body that check the spread of cancer.

> **Super-nutrition theory holds that you can "feed" the stops so that the body participates more effectively in the recovery and illness protection process.**

Nutrition and exercise ought to be protective factors. Unfortunately, for most, they are not.

On any given day, only 18 percent of Americans eat cruciferous vegetables (i.e., broccoli, radishes, watercress and brussels sprouts) and only 16 percent eat whole grains. The rest of us are eating junk food.

The **relationship between nutrition and immune function** has been recognized for many years. Malnutrition can impair the human body's defense mechanisms, decreasing resistance to infection.

While the immune function has been associated with AIDS research, it also plays an important role in the health status of people, including the elderly, who have high incidences of infectious disease.

> The changes that occur with aging are partly due to changes in nutritional status. By manipulating the diet appropriately, you may able to reverse or delay these changes.

Vitamin E is one of the few nutrients that has been shown to enhance immune functions and blood flow when taken in doses above the RDA. It may also help prevent heart disease; as an antioxidant, it also prevents the oxidation of LDL (low-density lipoprotein) cholesterol and the formation of blood clots.

Tests done on animals receiving various doses of vitamin E have indicated increased resistance to infectious diseases. So, vitamin E may help reduce the risk of infectious disease in the elderly—and anyone else for that matter—when taken in high doses.

Dieting does the most good by what it prevents. Being overweight increases your risk of diabetes, cardiovascular problems and several kinds of cancer. So, it's good not to be overweight.

> Losing weight and lowering your cholesterol will not make you healthy. These things will simply make you less unhealthy.

As we mentioned in the previous chapter, risk is relative. Being lean and in-shape doesn't make you healthy per se, but it makes you healthier as compared to being overweight and lethargic.

WATCH OUT FOR FAT AND SALT

The U.S. Surgeon General's Office has noted that in the 2000s, some 61 percent of Americans are overweight—up from 46 percent in the 1970s. More than ever, Americans enjoy cheap and convenient food—from McDonald's, KFC and Pizza Hut. But along with this convenience come **empty calories, refined sugars and artery-clogging fats**. This isn't good. As a society—and as individuals—Americans need to reverse that trend.

Why? Because epidemic obesity will lead to a health crisis as serious as AIDS, tuberculosis or anything else we've experienced. Obesity leads to diabetes, heart disease and other health problems. It causes or contributes to 300,000 deaths in America each year...and costs $117 billion in health care. And both of those numbers are going up.

Following current trends, **obesity will overpass smoking** as the number one preventable cause of death in America by 2020.

In the 1990s, the Department of Agriculture and the Department of Health and Human Services adjusted their guidelines for what a person's normal weight should be. The feds said that a "normal" 5-foot-6-inch woman under age 34 could weigh 118 to 155 pounds; over 35, she could weigh 130 to 167.

This upward adjustment is a dietary version of the phenomenon economists call **bracket creep** (when inflation raises the incomes of middle-class people into upper-class tax brackets). In this case, overweight people are reclassified as not overweight.

> Reclassifying guidelines to include heavier people in a "normal" category may make people feel better about themselves, but it hints at long-term trouble. Overweight people are two to six times more likely to develop hypertension; when they lose weight, there is a notable reduction in this risk (and others).

American Heart Association dietary guidelines emphasize reducing total fat (not just cholesterol) and keeping a balanced diet. In 1995, the AHA reduced its recommendation of no more than 30 percent of fat in the daily diet to no more than 20 to 25 percent. Less than 10 percent of the fat in the daily diet should come from saturated-fat (animal) sources. AHA dietitians insist that simple adjustments to the average balanced diet can achieve these goals.

Lowering fat intake can also reduce your risk of getting colon cancer. Fat is a factor that promotes colon cancer; the problem occurs when most calories are derived from fat. Colon cancer is the second leading cause of cancer deaths in men in America (lung cancer is first). The risk of colon cancer increases significantly over the age of 50.

And then there's salt. Research indicates that reducing sodium intake actually can prevent hypertension from developing. About 80 percent of consumed sodium comes from processed foods; 20 percent is added during preparation or at the table.

With fat and salt parameters set, you have considerable flexibility in **choosing a healthy diet**. But a few points are worth remembering:

- Potassium-rich foods, such as bananas, may play a role in the prevention of high blood pressure. The National Academy of Sciences estimates 1,600 milligrams a day to be a minimum goal. One banana provides about 450 milligrams of potassium. Other potassium-rich foods are cantaloupe, dairy products, orange juice, beans, broccoli and potatoes;

- You can still drink coffee in the morning—even with caffeine—without worrying about hypertension, as long as you drink it in moderation.

- Onions and garlic contain quercetin, which many scientists believe has a preventive role in heart disease linked to free-radical tissue damage, and S-allyl cysteine, which has been shown to lower levels of LDL.

- A USDA study found that as the substance homocysteine increases in older people, so does the risk of artery narrowing. Fortunately, folic acid can correct elevated homocysteine—and it's easy to get folic acid through your diet. Green vegetables and citrus are excellent sources.

An important caveat on dietary standards: Too little fat in the diet may be as risky as too much. Below 20 percent, key fat-soluble vitamins (A, D and E) may not be absorbed, and the body does not produce these essential fatty acids.

Essential fatty acids are necessary to prevent hardening of the arteries, increased risk of clot formation, high blood pressure and heart disease.

ALCOHOL RISK FACTORS

Alcohol is a dietary risk factor of unparalleled proportions. The complication: Some health experts say light or even **moderate alcohol** use may be *good* for you. Other statistics argue against this theory, though:

- A light drinker (who quaffs one pint of beer a day) faces a one in 50,000 chance of getting usually fatal cirrhosis of the liver in any single year. Over a drinking lifetime of 50 years, the odds narrow to one in 1,000.

- Heavy drinkers obviously face starker odds. Their odds of dying from the habit are one in 100.

And both of these projections only calculate disease. They don't count the even greater risk of accidents—in a car or on foot—when alcohol is involved.

Despite the statistics, other researchers still claim moderate drinking can lower death rates from other diseases—particularly coronary artery disease. The National Institute for Alcoholism and Alcohol Abuse (NIAAA) took a long look at this theory.

The NIAAA studied the alcohol and the heart "trade-offs" in a paper that asked the obvious question: "Will the cardioprotective effects of drinking outweigh the risks associated with alcohol use?"

The study described the mechanisms by which alcohol is thought to **protect against cardiac illness**, explored the potential risks and benefits of alcohol use and recommended a method by which people could determine the benefits and risks of alcohol use.

The study found that several plausible mechanisms support the possibility that drinking some alcohol protects against coronary artery disease. Of these, the best documented is protection by raising the high-density lipoprotein (HDL) or "good" cholesterol, and decreasing the low-density lipoprotein (LDL) or "bad" cholesterol that we mentioned earlier.

> The potent antioxidant activity of phenolic substances in red wine has been offered as an explanation of the French Paradox (the apparent incompatibility of a high-fat diet with a low incidence of coronary heart disease among French people).

The rest of alcohol's healthy impacts have to do with its **anti-clotting effects**: Alcohol increases the body's release of plasminogen activator, an enzyme involved in clot degradation. An anti-clotting effect would explain the apparent protective effect provided by relatively small amounts of alcoholic beverages.

For some people, moderate alcohol consumption appears to decrease risk of ischemic stroke, caused by blockage of blood flow in blood vessels. However, due to the anti-clotting effects of alcohol and the effect of alcohol on blood pressure, moderate drinking also increases the risk of hemorrhagic

stroke—caused by the loss of blood through the walls of a blood vessel.

DIET AND CANCER

The American Cancer Society has issued several dietary recommendations to improve your odds in cancer prevention. While the Cancer Society has bent risk analysis in some cases, its diet suggestions make basic sense. They include the following:

- **Avoid obesity.** This isn't just the five extra pounds that many people carry around, but being more than 10 percent overweight. Just because McDonald's opens a new restaurant somewhere every eight hours, doesn't mean you should eat there every day.

- **Cut down on total fat intake.** Keep saturated fat to a minimum; saturated fats come mostly from animal products, but also come disguised in many processed foods in the form of coconut oil and palm oil. So-called "trans-fatty acids" are a also something to avoid. Foods high in fat may increase cancers of the colon, breast and prostate.

- **Eat more high fiber foods.** Most Americans consume eight to 12 grams of fiber a day. The Cancer Society recommends at least twice that amount.

- **Add cruciferous (cabbage, cauliflower and broccoli) vegetables to your diet.** These are good sources of

cancer-preventing vitamins A and C. They are also naturally low in fat and contain fair amounts of fiber.

- **Cut down on salt-cured, smoked and nitrite-cured foods.** Foods are preserved to protect them from rapid spoilage. Some such methods have been found to be cancer-causing.

- **Keep alcohol consumption moderate.** The Cancer Society cites studies that show an increased risk of certain cancers in persons drinking as little as an average of two drinks daily. The risk tends to go up the more you drink.

DIET STRATEGIES

The best way to control the odds of diet-related risks is to take moderate steps toward a **balanced mix of foods and substances like vitamins and minerals**.

The key dietary rule: Lower the fat content of what you eat. In particular, watch out for those "bad" fats: saturated fats and trans fatty acids. After that, you should lower the amount of sodium you consume and raise the amount of fiber.

Tips from the American Dietary Association

☐ Examine nutrition labels. On individual foods with a nutrition label, check to see there are no more than 3 grams of fat for every 100 calories in a serving. When

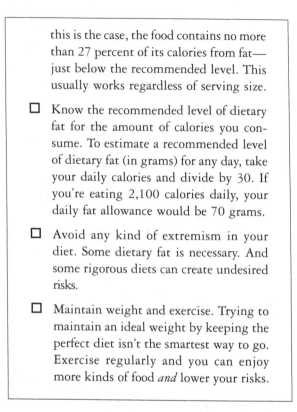

this is the case, the food contains no more than 27 percent of its calories from fat—just below the recommended level. This usually works regardless of serving size.

☐ Know the recommended level of dietary fat for the amount of calories you consume. To estimate a recommended level of dietary fat (in grams) for any day, take your daily calories and divide by 30. If you're eating 2,100 calories daily, your daily fat allowance would be 70 grams.

☐ Avoid any kind of extremism in your diet. Some dietary fat is necessary. And some rigorous diets can create undesired risks.

☐ Maintain weight and exercise. Trying to maintain an ideal weight by keeping the perfect diet isn't the smartest way to go. Exercise regularly and you can enjoy more kinds of food *and* lower your risks.

Don't expect dramatic health impacts from your diet. Diet is a **long-term, gradual protection**. Your best bet is to shave at mortality and life-span odds by eating a balanced, low-fat diet—including lots of mineral-rich fruits and vegetables...and engage in some form of physical activity to increase your heart rate.

Obviously, your weight has a lot to do with what you eat. But diet also affects your chances of contracting several types of cancer and fatal illnesses. As useful as specialized cancer insurance may be if you contract the disease...you've still contracted the disease. Dietary health factors are the best example of the im-

portance of prevention that you're likely to experience in your life.

> **Bottom line:** It's no mystery that a good diet will improve your chances for living a longer, healthier life. But a good diet is significant largely because it reflects a balanced, generally healthy approach to living. In this way, it's the opposite of fad diets designed to help someone look good by means of drugs or strange eating habits.

INSURANCE & OTHER TOOLS

The main insurance mechanism for protecting yourself against dietary risks is a **good health plan**.

If insurance companies consider you uninsurable due to your health or medical history, or if you are in the market for more than just your typical medical and hospitalization coverage, you might want to explore the options of other, less commonly used forms of health-related benefits or policies—on a stand-alone basis or combined with each other—including some of the following:

- health insurance that covers specific diseases;

- dental coverage;

- vision coverage;

- a separate prescription plan; or

- even long-term care coverage.

Of course, people look for these kinds of coverage precisely because they suspect they will have a particular kind of need. On the other hand, some people choose these coverages for financial reasons (i.e., their employers offer the insurance for free...or for a discounted fee via a tax-advantaged cafeteria plan).

Whatever the reason people choose specialty coverages, the plans will likely grow in importance as technology and financial sophistication advance.

Some risk experts predict that soon health insurance will be a collection of specialty coverages for specific conditions. This would allow maximum flexibility for the policyholder—and maximum precision for the insurance company.

Until then, specialty coverages remain...a specialty.

BEING A GOOD PATIENT

There's no better time to become an **aggressive consumer of medicine** than today. Despite the myth that doctors exist to protect patients, in reality, it's up to you to protect yourself, find the best care and ensure that the care delivered to you is right. No one is going to do any of these things for you, even if your life depended on it.

There are things you need to know and things you need to ask your provider if you expect to receive

the best care. Always keep in mind that **you are the communicator** to the health professional.

- Go into every detail of your symptoms and what ails you. No detail is trivial.

- Medicine is not an exact science. You are always part of the equation.

- Don't be afraid of doctors; make it a team effort when you enter a doctor's office.

- Part of a doctor's ability to arrive at correct diagnoses and suggest proper treatments is your ability to convey thorough and honest information.

Health Data You Should Know

☐ **Your weight**. Know what your weight is. Monitor it periodically. Consult with a nutritionist if you're having trouble with your diet.

☐ **Blood pressure**. About 50 million American adults have high blood pressure, also called hypertension. A blood pressure level of 140 over 90 mm Hg (millimeters of mercury) or higher is considered high. High blood pressure makes the heart work extra hard and hardens artery walls, increasing the risk of heart disease and stroke.

☐ **Personal medical history**. You must relate to your physician your previous medical history. This includes telling you

doctor about any procedures you've had done, surgeries, emergencies, etc. All of this information is valuable in making a correct diagnosis. Keep a written record of this information, as well as a record of your immunizations, past prescriptions, past tests and their results, etc. Did you have any serious illnesses? Were you hospitalized? If so, for what? All of this should be on your medical record.

☐ **Cholesterol and blood tests**. People ages 20 and older should have their cholesterol measured at least once every five years. If lifestyle changes alone don't adequately budge cholesterol levels, medications may be needed. Other things can be tested during routine blood tests, including diabetes and leukemia. Men over 50 should also request a special PSA (prostate-specific antigen) test to check their prostate, as elevated PSA levels are a possible indicator of cancer.

☐ **Medications that you take and have taken**. Keep a record of the medications you take. If you have any questions about your medications and their contraindications, you should consult your pharmacist or doctor.

☐ **Family history**. Giving your doctor an idea of what your family health history is like, is key to his or her ability to keep you healthy. At the end of this chapter there is a sample family health pedigree. You should construct a similar one using

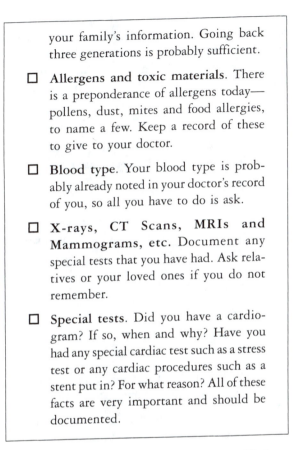

your family's information. Going back three generations is probably sufficient.

☐ **Allergens and toxic materials**. There is a preponderance of allergens today— pollens, dust, mites and food allergies, to name a few. Keep a record of these to give to your doctor.

☐ **Blood type**. Your blood type is probably already noted in your doctor's record of you, so all you have to do is ask.

☐ **X-rays, CT Scans, MRIs and Mammograms, etc.** Document any special tests that you have had. Ask relatives or your loved ones if you do not remember.

☐ **Special tests**. Did you have a cardiogram? If so, when and why? Have you had any special cardiac test such as a stress test or any cardiac procedures such as a stent put in? For what reason? All of these facts are very important and should be documented.

If you have all this information, you're more likely to receive the best medical care and help direct the course of your treatment(s) with your doctor...when you need it most.

BEATING STRESS

If there's one chronic "illness" we all have these days, it's stress. **Chronic anxiety** has been linked to all sorts of serious illnesses and disease. Your risk of having a

heart attack, for example, is heightened by the level of stress in your life. Daily problems related to stress include tension headaches, migraines, high blood pressure, an upset stomachs and neck and back pain.

> Chronic headaches—particularly tension headaches—can be a sign that your life is out of balance.

Take inventory of what causes stress in your life and make realistic changes. Examples of positive changes include:

- Getting more sleep;

- Eating breakfast;

- Scheduling winding down time a half an hour before going to bed;

- Reducing the number of responsibilities and tasks you take on;

- Learning how to delegate at work and prioritize;

- Considering massage sessions, relaxations exercises (meditation, hypnosis, yoga, etc.), physical exercise;

- Considering a move to a more tranquil town or closer to work so your commute isn't so bad; and

- Consulting with a psychologist to improve stress management.

A doctor can prescribe certain medications to help, but talk about the option with your doctor.

HEART DISEASE

Heart disease is the **leading cause of death** for both men and women in the U.S. Every year, more than 1 million people have heart attacks, according to the National Heart, Lung and Blood Institute (NHLBI). About 13 million Americans have coronary heart disease; about half a million die from it each year.

> Risk factors for heart disease are typically labeled "uncontrollable" or "controllable." The main uncontrollable risk factors are age, gender and a family history of heart disease.

The risk of heart disease rises as people age, and men tend to develop it earlier. Specifically, men ages 45 and older are at increased risk of heart disease, while women 55 and older are at increased risk. A woman's natural hormones give some level of protection from heart disease before menopause.

Tips for Minimizing Heart Disease Risk

☐ Know if you have uncontrollable risk factors for heart disease;

☐ Learn about the controllable risk factors:

physical inactivity, smoking, overweight or obesity, high blood pressure, high blood cholesterol, and diabetes; and

☐ Incorporate change into your lifestyle to counter any of these risk factors.

GET ACTIVE

Exercise improves heart function, lowers blood pressure and blood cholesterol and boosts energy. And, being overweight forces the heart to work harder.

About one in four U.S. adults is sedentary. Thirty-four percent of U.S. adults are considered overweight, and an additional 31 percent are obese.

Anyone with a body mass index (a ratio between your height and weight) of 25 or above—for example, someone who is 5-foot-4 and 145 pounds—is considered overweight, according to the National Institutes of Health. Anyone with a body mass index of 30 or above—such as someone who is 5-foot-6 and 186 pounds—is considered obese. (You can find a copy of the body mass index chart and calculator online at many sites, including *www.consumer.gov/weightloss* or *www.nhlbi.nih.gov/guidelines/obesity*, among others.) Suggestions for getting active include:

- Get at least 30 minutes of moderate physical activity on most, and preferably all, days of the week.

- You can divide up those minutes into 10-minute intervals throughout your day.

- The more vigorous the exercise, the bigger the benefits.

The drug class known as "statins" marks a significant advance in preventing heart disease. These drugs work by partially blocking the synthesis of cholesterol in the liver, which helps remove cholesterol from the blood. Along with lowering cholesterol, statins help stabilize blood vessel membranes. Even with drug treatment, a cholesterol-lowering diet and exercise are still recommended.

Other Health Tips

☐ **Prevent and manage diabetes.** About 17 million people in the United States have diabetes, and heart disease is the leading cause of death of those with the disease. According to the American Diabetes Association (ADA), two out of three people with diabetes die from heart disease or stroke.

☐ **Quit smoking.** Smokers have more than twice the risk of having a heart attack as non-smokers.

☐ **Recognize the signs of a heart attack.** These include: chest discomfort or pain, discomfort in the arm(s), back, neck, jaw or stomach, shortness of breath, breaking out in a cold sweat, nausea and

lightheadedness. (Heart attack symptoms for men can be different than symptoms for women. For women, it may present as back pain, flu-like symptoms or a sense of impending doom.)

☐ **Be wary of fad diets**. If it looks too good to be true, it probably is. No pill, cream, lotion or potion will melt pounds off your body; only diet and exercise will.

☐ **Recognize signs that mean you need to get yourself to the emergency room**. These include: sudden to severe pain that doesn't go away; difficulty breathing or unusual shortness of breath; a headache with a stiff neck or fever; coughing or vomiting blood; uncontrolled bleeding of any kind; and unexplained weight loss or loss of appetite.

SOMEONE AT HOME IS SICK

Avoiding sickness when someone in your home is down with a cold or flu can be a challenge. You'll want to minimize the spread of germs so other family members—including yourself—remain healthy. Some **tips for staying healthy**:

- Get enough sleep and exercise. Both boost your immunity;

- Wash your hands like crazy. Scrub up every time you wipe a runny nose or change a diaper, as well as every time you sneeze or visit the bathroom;

- Leave leftovers alone. Avoid polishing off someone else's plate.

- Avoid sharing lip balm or other personal items that can contain germs (unwashed glasses, make-up, toothbrushes, etc.);

- Wash clothing regularly. A clean top won't guarantee that you'll avoid the germs, but it's better than a dirty one that Little Mary sneezed on; and

- If you begin to get flu symptoms or a bad sore throat, call your doctor and ask about antiviral drugs that lessen its severity and duration.

If you feel like you're coming down with a cold or bug, be careful when coming into contact with other people. **Wash your hands. Drink more fluids than usual.** Alert others to your illness and do your best to avoid public places. In other words, if you're sneezing and coughing, don't go to the movies and spread your germs to others in the theatre.

CONCLUSION

When it comes to personal security, maintaining your health ranks high on the list of things you can do to manage your safety and protect yourself. When you think about it, the healthier you are, the better you're able to think clearly, act quickly, make smart decisions...and avoid serious illness.

In Appendix B you'll find the **USDA's Food Guide Pyramid** and in Appendix C, a sample family pedigree from which to create your own.

This book has considered the various things that can pose serious risks to the life, health and well-being of you...and those people closest to you. It has covered the breadth (or *most* of the breadth) but not always the depth of personal security issues in our modern world.

If any of the topics covered by this book seems to be particular importance to you, your family and the way you live, we encourage you to investigate further. You can start by going to Silver Lake Publishing's Web site (www.silverlakepub.com) for other books and information on the issues we've covered here.

> Most importantly, we hope that this book has made the point that the only institution that can provide effective security for you and your family is...you.

No government, no agency, no hired profesional knows as much about you and the people closest to you as you yourselves do. You have the interest; you have the insight. You know best what your risks are— and the best ways to minimize them.

We hope this book is a useful guide to finding those best ways.

APPENDIX A

HOME SECURITY
CHECKLIST

This is a guide for checking your home for safety measures. Boxes marked "no" indicate areas where you could take action to improve your home's security.

Exterior Doors	Yes	No
All doors are locked at night and every time you leave—even for a few minutes.	☐	☐
Doors are solid hardwood or metal-clad.	☐	☐
Doors feature wide-angle peepholes at heights everyone can use.	☐	☐
If there are glass panels in or near doors, they are reinforced so that they cannot be shattered.	☐	☐

All entryways have a working, keyed entry lock and sturdy deadbolt lock installed into the frame of the door. ☐ ☐

Spare keys are kept with a trusted neighbor, not under a doormat or planter, on a ledge, or in a mailbox. ☐ ☐

Garage and Sliding Door Security

	Yes	No
The door leading from the attached garage to the house is solid wood or metal-clad and protected with a quality keyed door lock and deadbolt.	☐	☐
The overhead garage door has a lock so that we do not rely solely on the automatic door opener to provide security.	☐	☐
All garage doors are locked when leaving the house.	☐	☐
The sliding glass door has strong working key locks.	☐	☐

A dowel or a pin to secure a glass door has been installed to prevent the door from being shoved aside or lifted off the track. ☐ ☐

The sliding door is locked every night and each time we leave the house. ☐ ☐

Protecting Windows	Yes	No

Every window in the house has a working key lock or is securely pinned. ☐ ☐

Windows are always locked even when they are opened a few inches for ventilation. ☐ ☐

Outdoor Security	Yes	No

Shrubs and bushes are trimmed so there is no place for someone to hide. ☐ ☐

There are no dark areas around our house, garage or yard at night that would hide prowlers. ☐ ☐

Floodlights are used appropriately to ensure effective illumination.

☐ ☐

Outdoor lights are on in the evening— whether someone is at home or not, or a motion-sensitive lighting system has been installed.

☐ ☐

Your house number is clearly displayed so police and emergency vehicles can find the house quickly.

☐ ☐

Security When Away From Home

	Yes	No

At least two light timers have been set to turn the lights on and off in a logical sequence when we are away for an extended time period.

☐ ☐

The motion detector or other alarm system (if we have one) has been activated when we leave home.

☐ ☐

Mail and newspaper deliveries have been stopped or arrangements for a neigh-

☐ ☐

bor/friend to pick them up
have been made when we
go away from home for a
period of time.

A neighbor has been asked ☐ ☐
to tend the yard and watch
your home when you are
away.

Outdoor Valuables and Personal Property

	Yes	No
Gate latches, garage doors and shed doors are locked with high-security, laminated padlocks.	☐	☐
Gate latches, garage doors and shed doors are locked after every use.	☐	☐
Grills, lawn mowers and other valuables are stored in a locked garage or shed, or if left out in the open, are hidden from view with a tarp and securely locked to a stationary point.	☐	☐
Every bicycle is secured with a U-bar lock or quality padlock and chain.	☐	☐

Bikes are always locked, even if you leave them for just a minute. ☐ ☐

Firearms are stored unloaded and locked in storage boxes and secured with trigger guard locks. ☐ ☐

Valuable items, such as television, stereos and computers have been inscribed with the identifying number approved by local police. ☐ ☐

Your home inventory is up-to-date and includes pictures. A complete inventory is kept somewhere out of the house. ☐ ☐

FOOD GUIDE

PYRAMID

Food Guide Pyramid

A Guide to Daily Food Choices

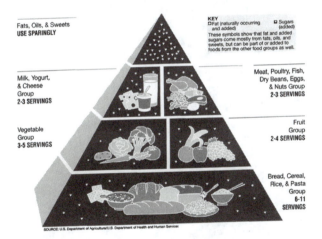

KEY
□ Fat (naturally occurring and added) ◻ Sugars (added)

These symbols show that fat and added sugars come mostly from fats, oils, and sweets, but can be part of or added to foods from the other food groups as well.

Fats, Oils, & Sweets
USE SPARINGLY

Milk, Yogurt, & Cheese Group
2-3 SERVINGS

Meat, Poultry, Fish, Dry Beans, Eggs, & Nuts Group
2-3 SERVINGS

Vegetable Group
3-5 SERVINGS

Fruit Group
2-4 SERVINGS

Bread, Cereal, Rice, & Pasta Group
6-11 SERVINGS

SOURCE: U.S. Department of Agriculture/U.S. Department of Health and Human Services

Use the Food Guide Pyramid to help you eat better every day. . .the Dietary Guidelines way. Start with plenty of Breads, Cereals, Rice, and Pasta; Vegetables; and Fruits. Add two to three servings from the Milk group and two to three servings from the Meat group.

Each of these food groups provides some, but not all, of the nutrients you need. No one food group is more important than another — for good health you need them all. Go easy on fats, oils, and sweets, the foods in the small tip of the Pyramid.

FAMILY HEALTH
PEDIGREE

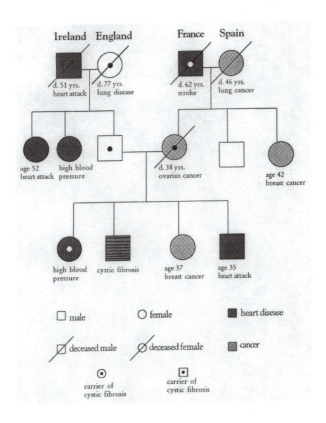

INDEX